CM00799163

MASTERPIECES

MASTERPIECES

FROM
BUCKINGHAM PALACE

DESMOND SHAWE-TAYLOR
AND
ISABELLA MANNING

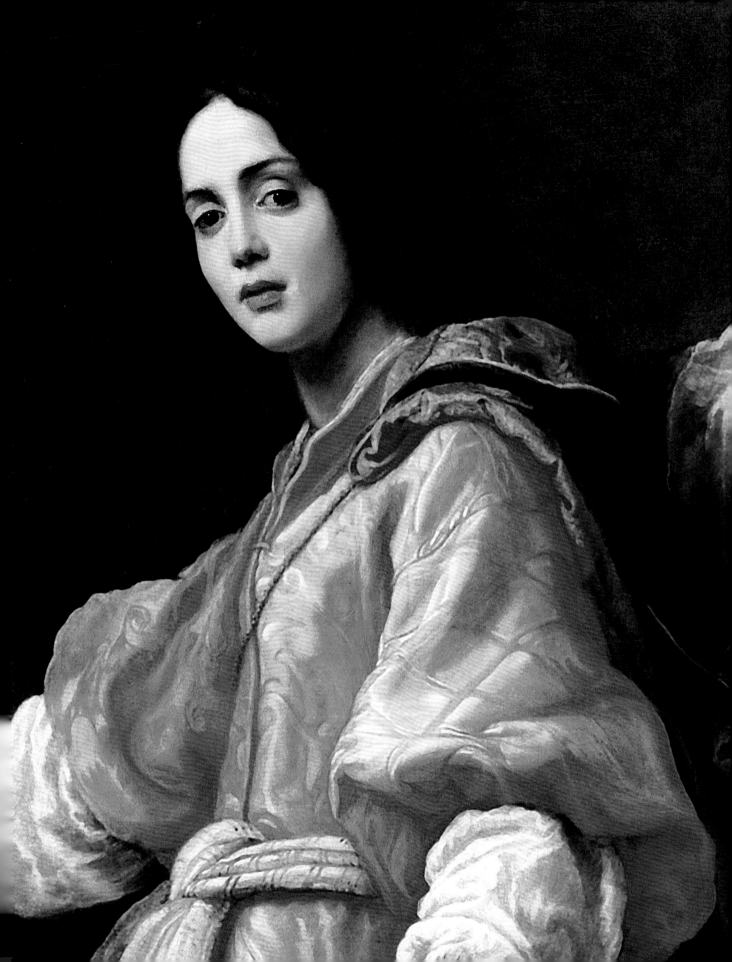

Contents

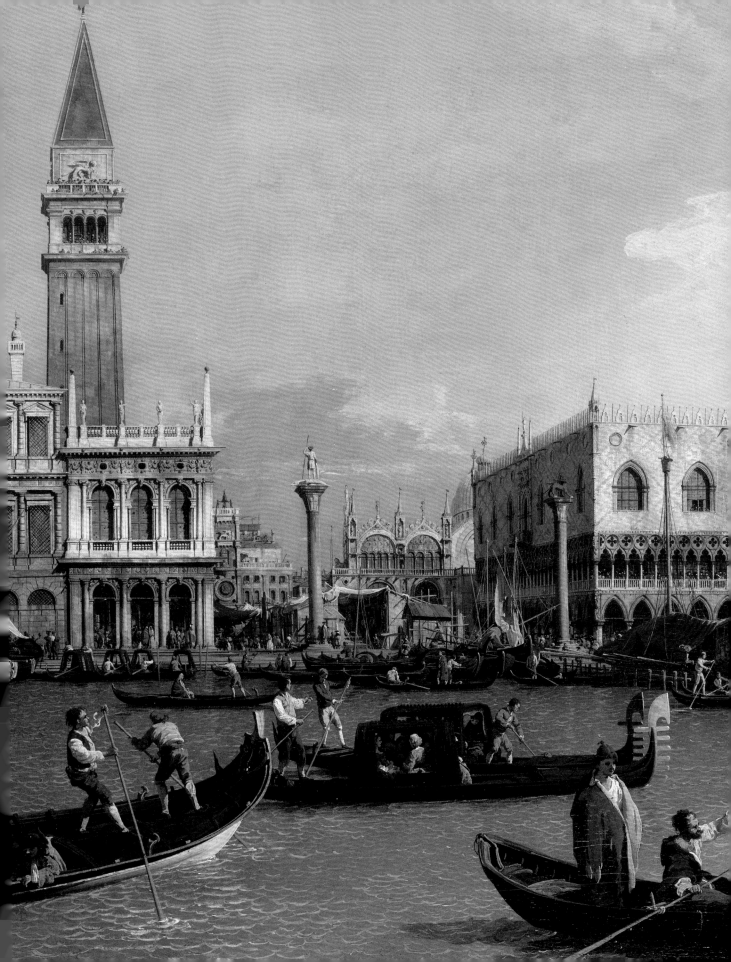

Old Master Paintings at Buckingham Palace

Isabella Manning

Since 1762, the year that George III and Queen Charlotte purchased Buckingham House, great Old Master paintings from the Royal Collection have been displayed there. The King and Queen set a precedent for carefully arranged picture hangs, which George IV intended to continue by providing a picture gallery for his collection of Dutch masterpieces. Under Queen Victoria and Prince Albert the gallery was used as a space for entertaining, but the picture arrangements were largely left alone as the royal couple focused their attention elsewhere. In the twentieth century, displays in the gallery were refreshed, re-establishing a tradition that pre-dates royal ownership.

Even before George III and Queen Charlotte acquired the house from the Duke of Buckingham, the collection of pictures was renowned and much care was taken over its presentation. Nevertheless, in an eighteenth-century account of his closet at Buckingham House, the Duke compared

the pictures unfavourably with the view over St James's Park: 'the first room of this floor has within it a closet of original pictures, which are yet not so entertaining as the delightful prospect from the windows'. An inventory of the closet establishes that it was hung with drawings by Holbein and paintings by Tintoretto, Giorgione, Claude, Bassano, Carracci, Parmigianino and Poussin, among others, providing strong competition against the picturesque views. In the same account of his house, the Duke described hangs in other rooms, including one 'adorned with paintings relating to Arts and Sciences; and underneath divers original pictures hang all in good lights, by the help of an upper row of windows, which drown the glaring'. The extent to which pictures have been arranged by subject matter and school, and the importance of good lighting, have consistently preoccupied those in charge of their arrangement. Other considerations, including interior architecture, framing and changing tastes in the history of collecting, continue to affect the display of Old Master paintings at Buckingham Palace.

Canaletto, *The Bacino di San Marco on Ascension Day*, detail of cat. 23

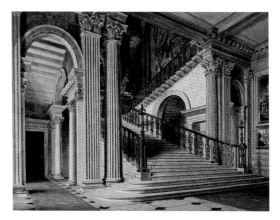

2

Richard Cattermole (?1795–1868), *The Entrance Hall and Staircase, Buckingham House*, 1817, pencil, watercolour and bodycolour, 20.8 × 26.1 cm, RCIN 922139

1

James Stephanoff (1789–1874), *The Staircase, Buckingham House*, 1818, pencil, watercolour and bodycolour, 25.1 × 20.0 cm, RCIN 922138

Buckingham House, which became known as the 'Queen's House' after 1762, was intended as a retreat for Queen Charlotte and provided an antidote to official court life at St James's Palace. Almost immediately, the architect William Chambers was employed to draw up designs for adapting the building. Although magnificent murals of Dido and Aeneas by Louis Laguerre remained on the staircase (Fig. 1), documents pertaining to the sale record that no hanging paintings were included in the purchase. The royal couple set about sourcing pictures to fill their new house, and 214 had been hung by around 1790.

The pictures were obtained from several sources. The first was the King's father, Frederick, Prince of Wales, who had owned a rich collection of seventeenth-century Italian and Flemish paintings at Leicester House. By around 1790, 33 pictures formerly belonging to Frederick were hanging at Buckingham House. A high concentration of these were in the King's Dressing Room, one of the most private rooms in George III's apartments, suggesting a certain admiration for his father's collection. The hang replicated a room at Leicester House described by George Vertue, the engraver and antiquary, in which the same Italian landscapes by Claude Lorrain and Gaspar and Nicolas Poussin had been displayed. Other Italian paintings that Vertue recorded as being among Frederick's prized possessions were also hung in Buckingham House, including two paintings then attributed to Guido Reni (including cat. 11) and two by Andrea del Sarto.

George III's purchase of the large collection of Joseph Smith, the British Consul in Venice,

in 1762 further enriched the displays of Italian paintings at Buckingham House. The sale included many works by Canaletto, whose portrait-format Roman views were hung in the Hall above architectural scenes by Francesco Zuccarelli and Antonio Visentini. The pictures were arranged within panels, framed at regular intervals by Corinthian pilasters (Fig. 2). These features complemented the Palladian architecture depicted by Visentini and Zuccarelli, and made reference to Canaletto's views of Roman monuments such as the Pantheon, which had directly inspired Palladio's classicism. It has been presumed that Smith's collection was purchased solely in order to furnish the new house. However, by around 1790 only 34 of more than 500 paintings acquired from Smith were hanging at Buckingham House. Of these, 32 were Italian pictures.

As well as new acquisitions, the King and Queen sourced paintings from the recently inherited royal collection. In 1762–3, Stephen Slaughter, Surveyor of the King's Pictures, compiled an inventory of the paintings at Kensington Palace, Hampton Court and Windsor Castle, probably to establish which works to move to Buckingham House. Renowned Old Masters were transferred there, including Sir Anthony van Dyck's two monumental portraits of *Charles I with M. de St Antoine* and *Charles I and Henrietta Maria with their Two Eldest Children, Prince Charles and Princess Mary ('The Greate Peece')*, both taken from Kensington and hung in the Japan Room at Buckingham House. In December 1763 the Raphael Cartoons were removed from Hampton Court and hung in the Queen's Saloon. The few contemporary observers who were admitted admired their presence there, including Horace Walpole, who described them as hanging on 'light green damask'. Later hanging

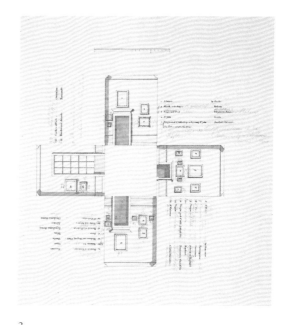

3

Unknown, *Plan of the Picture Hang in the King's Closet, Buckingham House*, c.1774, pencil, pen and ink, 52.5 × 37.6 cm, RCIN 926313

plans of c.1774 record the tight arrangement, the wall colour and the lighting, with the top-tier windows providing extra illumination for the works. Other commentators praised their transferral to London but lamented the lack of public access. Nevertheless, the arrival of the Cartoons at Buckingham House reinforced its reputation as a key location for the display of important Old Master works.

Hanging plans were used to work out later displays in other rooms at Buckingham House, and their rare survival brings the picture arrangements to life. In keeping with eighteenth-century approaches to picture hanging, the King and Queen grouped paintings by school and by genre. In the King's Apartments on the ground floor, the Dressing Room was hung with 14 landscapes, the

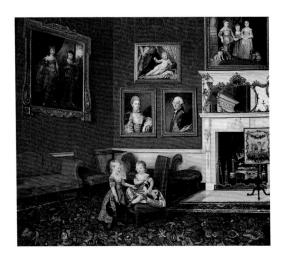

4
Johan Joseph Zoffany (1733–1810), *George, Prince of Wales, and Frederick, later Duke of York, at Buckingham House*, 1765, oil on canvas, 111.9 × 127.9 cm, RCIN 404709

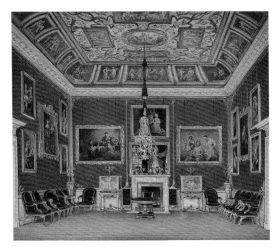

5
James Stephanoff (1789–1874), *The Second Drawing Room, Buckingham House*, 1818, pencil, watercolour and bodycolour, 19.8 × 24.9 cm, RCIN 922143

Passage Room with Flemish portraits, the Drawing Room with religious and history paintings and the Closet with many small-scale Italian religious scenes. The inclusion of frame details, dimensions, light direction and architectural features on the plans left little to chance and heightened the use of symmetry to create visually striking displays. The presence of the King's own handwriting on the plans reveals the extent to which he was involved. For his Closet, the King drew up an initial sketch to map out the arrangement. Subsequent versions contain additional suggestions in another hand, such as the inclusion of two works by Carlo Dolci and Elisabetta Sirani on either side of a central painting by Garofalo on the wall opposite the window (Fig. 3). A comparison with an inventory of *c*.1790 shows that these plans were carried out almost exactly.

The care taken over the picture hangs was evident to visitors. In 1786, Sophie von La Roche,

a German novelist, commented on the 'delightful order and simplicity reigning everywhere'. Whereas the King's rooms were certainly simply arranged, with no carpets and monochrome walls, the Queen's rooms on the principal floor were more elaborately decorated. The Queen's Warm Room, also known as the Second Drawing Room, was captured in 1765 by Johan Zoffany (Fig. 4) and in 1818 by James Stephanoff (Fig. 5). In Zoffany's painting, a fireplace designed by William Chambers and a Brussels carpet create an impression of opulence. The rich crimson damask on the walls was considered the best backdrop for picture displays at the time. While there is no surviving record of the picture hang in 1765, it is probable that Zoffany cherry-picked choice paintings for his composition. In keeping with contemporaneous inventories, Stephanoff's later watercolour gives a more accurate insight into the display, organised by school and genre. Beneath a

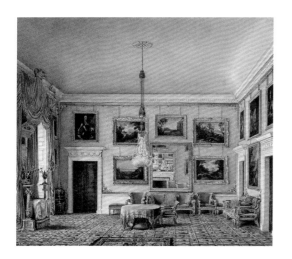

6

Charles Wild (1781–1835), *The Blue Velvet Room, Buckingham House*, 1817, pencil, watercolour and bodycolour, 19.6 × 24.9 cm, RCIN 922144

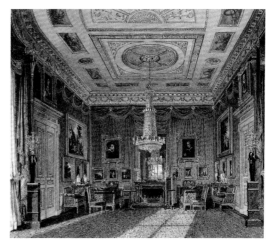

7

Charles Wild (1781–1835), *The Rose Satin Drawing Room, Carlton House (Looking North)*, c.1817, pencil, watercolour and gum arabic, 20.6 × 27.0 cm, RCIN 922180

ceiling by Giovanni Battista Cipriani, the pictures on each wall were arranged around a central portrait by van Dyck, framed on the left wall by Italianate images of the Virgin and Child, and on the right with paintings by Bolognese artists Reni and Guercino. In the early nineteenth century, when the King moved to Windsor, the Queen incorporated some pictures from his rooms into her apartments. For instance, ten landscapes by Claude, Poussin and Rubens that had previously hung in the King's Dressing Room were rehung in grander circumstances in the Blue Velvet Room (Fig. 6). These arrangements endured until the Queen's death in 1818. The carefully organised picture hangs were clearly intensely personal and therefore well suited to the private, domestic life that the royal family led at Buckingham House. The future George IV grew up in these rooms, and the hang must have influenced his similarly thoughtful arrangements at Carlton House,

his residence as Prince of Wales and also as Prince Regent.

George IV displayed his collection of Dutch masterpieces in a series of rooms on the garden front of Carlton House, alongside elaborate swagged drapery, candelabra and mirrors. In the Bow Room or Rose Satin Drawing Room, for instance (Fig. 7), large landscapes by David Teniers the Younger and Aelbert Cuyp were hung above smaller Dutch genre scenes by Gerrit Dou, Philips Wouwerman and Adriaen van de Velde in arrangements of one large painting over three smaller paintings. The picture hangs throughout Carlton House were similarly intimate and precise. However, after he became King in 1820, it was clear that the relatively small scale of the house would not match up to the extravagance of his rule. George IV's collection was outgrowing the house, with many paintings kept in store. It is no surprise, therefore, that the expansion of

Buckingham House included a gallery to provide an even grander setting for the optimum display of his outstanding paintings.

In the eighteenth and early nineteenth centuries, picture galleries were becoming a more common feature of London townhouses. One of the most renowned was at Cleveland House, built by the Marquess and Marchioness of Stafford in 1803–6 and documented in a set of etchings (Fig. 8), which record conventional patterns of hanging. In some cases, much like at Carlton House, a large picture anchored the display, with smaller cabinet pictures arranged underneath at a height that enabled close viewing of details. In other cases, a larger picture hung centrally on the wall, with symmetrical arrangements around it, organised in two or three tiers. London galleries such as Cleveland House became important social spaces and George IV was among the fashionable elite who frequented parties held in them. It is probable that he had such examples in mind when he drew up plans for his own picture gallery.

By 1821, the new King had his sights set on Buckingham House as a pied-à-terre, and renovations began in 1825, led by architect John Nash. By 1826, the scope of the project had changed to become the King's primary palace, which led to the provision of even more spectacular interiors. The Picture Gallery was created by knocking through the enfilade of rooms used by Queen Charlotte on the principal floor, and enclosed by a new suite of rooms added on the garden side. George III's former rooms on the ground floor were gutted to create a sculpture gallery below. In other London townhouses, picture and sculpture galleries were increasingly being treated separately. In the case of Buckingham Palace, one of George IV's key advisers, Charles

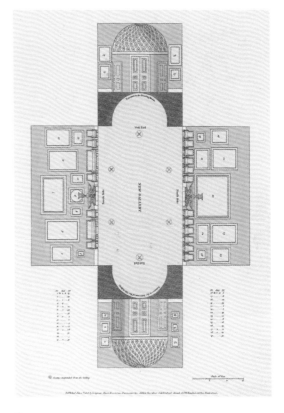

8
Published by Longman, Hurst, Rees & Orme, *Marquess of Stafford's Gallery, London*, 1808, hand-coloured etching, RCIN 702413

Long, Lord Farnborough, probably influenced the division. He designed a similar arrangement at his country house, Bromley Hill, in Kent.

The standard design for picture galleries, established in the eighteenth century, continued to be employed for public and private galleries during the early nineteenth century, including at Cleveland House and Sir John Soane's Dulwich Picture Gallery (opened 1817). It consisted of a long, rectangular top-lit room with tall walls, often terminated at either end by columned

screens. Nash's Picture Gallery at Buckingham Palace followed this tradition, complete with a columned screen at the south end. The addition of rooms on the garden side of the Gallery forced the use of top-lighting, and Nash made a feature of the ceiling. The striking hammerbeam design had pendant arches and domes running the length of the Gallery on both sides. These Gothic elements were probably inspired by Soane, who used similar hanging arches in projects at the Court of Chancery and in the Picture Room of his own house at Lincoln's Inn Fields. However, Nash's ceiling was a case of style over function, and in 1831 the lighting was criticised because 'not a picture can be seen with its proper effect'. William Seguier, Surveyor of the King's Pictures, proposed an additional lantern-light to run down the centre of the Gallery to improve these conditions. This was later implemented by Edward Blore, the architect appointed to the project after Nash's dismissal in 1830.

Nash's interventions in the palace featured the extensive use of real and imitation marble (scagliola). The four chimneypieces in the Picture Gallery were designed by Nash and made by Joseph Browne in Carrara marble. Each fireplace surround has a central medallion, carved with portraits of Titian, Dürer, Leonardo and van Dyck (Fig. 9). A fifth chimneypiece depicting Rembrandt was moved to the East Gallery by Blore. Elsewhere in the Picture Gallery, imitation marble was used to create impressive friezes and doorcases, framed by busts on pillars and topped with elaborate arrangements including coats of arms and vases. Royal symbolism continued in the ceiling, with European chivalric orders on either side of the central lanterns.

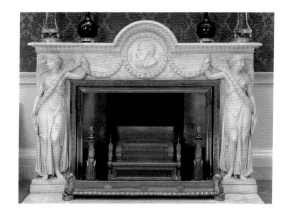

9
Joseph Browne (*fl.* 1825–50), *Chimneypiece with portrait of Titian*, 1825–35, marble, 145.0 × 233.0 × 57.0 cm, RCIN 68871.4

George IV died in 1830 and never saw the completed Gallery. His younger brother and successor, William IV, took little interest in Buckingham Palace and instead focused his energies on Hampton Court and St James's Palace. Nevertheless, work continued during his reign under the supervision of Viscount Duncannon, First Commissioner of Woods and Forests. In 1826 the pictures intended for Buckingham Palace had been removed from Carlton House and from 1830 they were kept in store at 105 Pall Mall. When the German art historian and museum director Gustav Friedrich Waagen visited London in August 1835, they were still there, kept 'in such a manner, that only a few of the pictures can be seen in a perfectly satisfactory manner'. By 1836, the Gallery was hung, and, when the German artist Johann David Passavant was admitted, he declared it 'the most perfect assemblage of Dutch pictures I know'. Work probably continued after Queen Victoria moved into the palace on 13 July 1837.

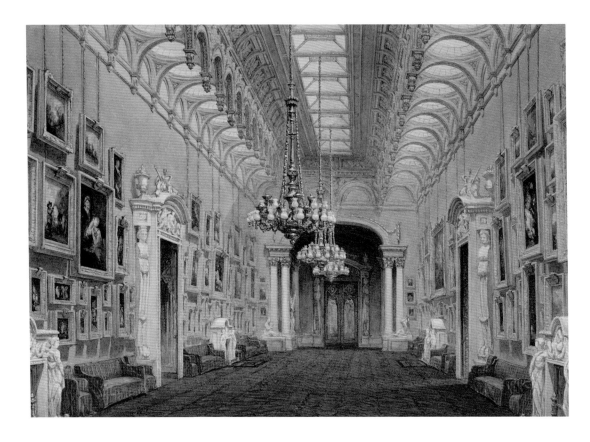

10

Douglas Morison (*fl.* 1814–47), *The Picture Gallery, Buckingham Palace*, 1843, pencil, watercolour and bodycolour, 27.7 × 39.0 cm, RCIN 919916

Nash's Picture Gallery had the potential to re-define the presentation of pictures in Buckingham Palace, but the first hang was something of an anti-climax (Fig. 10). In 1844 the art historian Anna Jameson declared the arrangement unsuc-cessful, the space 'too lofty' and the lighting 'not well contrived for such small and delicate pictures', and lamented that some of the pictures 'hang so high, almost out of sight'. The busy and confused display departed entirely from the ordered symme-try of its predecessors at Buckingham House and Carlton House and from contemporary London galleries. There were no evident tiers, and the pictures were not all hung by size. It seems unlikely that the arrangement derived from any original plans drawn up by George IV or his advisers. Jameson, similarly unimpressed by the State Apartments at Hampton Court, asked to whom blame for hanging the royal residences should be assigned: 'Is it to the Lord Chamberlain and his deputies? Or to Lord Duncannon and his depu-ties? Or Mr Seguier and his deputies?' The last two names, Duncannon and Seguier, seem most likely in the case of Buckingham Palace.

Duncannon worked closely with Queen Adelaide on the decoration and the arrangement of the

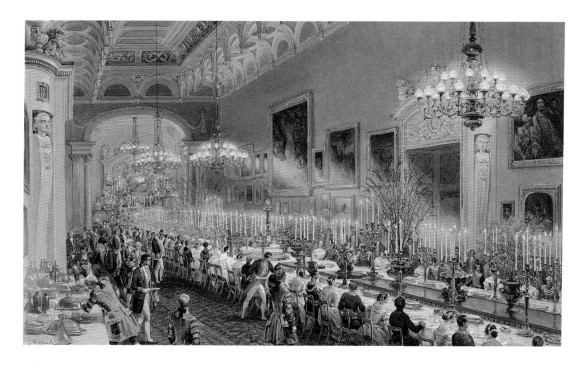

11
Louis Haghe (1806–85), *The Banquet for Prince Leopold's Christening, 28 June 1853*, 1853, pencil, watercolour and bodycolour, 33.0 × 37.4 cm, RCIN 919917

furniture in the drawing-rooms, and it is possible that they also made decisions about the appearance of the Picture Gallery. The yellow damask seen in Douglas Morison's view of 1843 was used in other contemporaneous galleries – at Apsley House, and in the houses of Sir John Soane and John Julius Angerstein.

Seguier was an art adviser, conservator and first Keeper of the National Gallery. He served as Surveyor for George IV, William IV and Queen Victoria and was thus responsible for the royal collection of pictures when the Gallery was first hung. Presumably he therefore had some input into the organisation of the display. Seguier was, however, subject to frequent ridicule by art

historians, artists and intellectuals. In publicly printed character assassinations, contemporaries derided his expertise, and, in an obituary, George Darley damningly expressed the superficiality of Seguier's art historical knowledge as 'chiefly, or altogether, anecdotical [*sic*] and traditional; he could cite a pleasant tale about Claude when pastrycook, or tell what Cromwell said about his warts to the portraitist … but a deeper vein of criticism is, we trust, now in demand'.

Seguier's 'expertise' rested with the art of the Low Countries, which did not align him with the preferences of Queen Victoria. In her journal entry for 31 July 1839 the Queen described a conversation with Lord Melbourne, when they discussed 'the beautiful pictures in the Gallery here [Buckingham Palace], for some time; of their all being Dutch, which we agreed was a low style; our preferring the Italian Masters'. Although

the Queen did acquire some Dutch and Flemish pictures, she shared a preference for Italian paintings with Prince Albert, who took a keen interest in picture collecting and displays across the royal residences. It is perhaps surprising, therefore, that in Seguier's 1841 inventory of the Picture Gallery all but 18 of the 185 pictures on display were Dutch and Flemish. The predominance of the two schools continued throughout the rest of the nineteenth century, suggesting that the Gallery was not a top priority for the royal couple. It was, however, the main space for entertaining until the Ballroom was completed in 1854, and required an appearance appropriate for state functions. In 1850–1 it was redecorated and rehung for the first time during Queen Victoria's reign (Fig. 11). In her journal on 4 February 1851 the Queen commented: 'we went over the new wing … & walked through the Gallery which has been fresh painted, dove colour, and all the pictures have been framed and rehung which makes them look beautiful'. Presumably the 'dove colour' refers to the lilac walls, considered fashionable at the time, but not necessarily suited to the decoration of picture galleries. Further colour was applied to the ceiling, in which decorative elements were highlighted in terracotta, blue and gold. The scheme created continuity with other brightly coloured State Rooms in the palace decorated by Prince Albert and his artistic adviser, Ludwig Grüner, in a style influenced by the Italian Renaissance.

In the same year Prince Albert systematically reframed every painting in the Gallery, replacing the deep Regency frames commissioned by George IV. William Thomas of Fitzroy Square made the new composition frames. The reverse-moulded pattern ensured that the shadows cast by the lighting in the Gallery were minimised. Although this could be read as an indication of

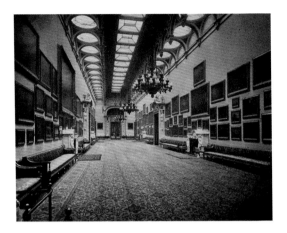

12

Hills & Saunders, *The Picture Gallery, Buckingham Palace*, 1873, carbon print, 14.8 × 19.6 cm, RCIN 2101721

Prince Albert's concern for the Dutch pictures, it was more probably a result of his persistent search for visual uniformity, also seen in his reframing of the royal collection miniatures.

The Surveyor of the Queen's Pictures, Thomas Uwins, recorded the rearrangement in an 1852 catalogue. Only four of the pictures hanging in the Gallery had been acquired by Prince Albert and Queen Victoria, including two paintings by Jean-Baptiste Greuze (both now attributed to followers of Greuze) and two by Rubens (one of which has since been attributed to Abraham van Diepenbeeck). Apart from a few paintings collected by George III, the rest had been acquired by George IV. Although the number of pictures remained roughly the same (185 in 1841 versus 182 in 1852), the arrangement had become even more focused on the Dutch and Flemish schools. Between 1841 and 1852 the majority of the British pictures were removed, including works by William Allan, David Wilkie and Zoffany. Three pictures by Joshua Reynolds remained, one by Poussin and one by Titian, perhaps in

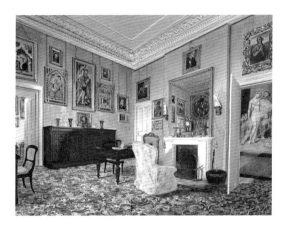

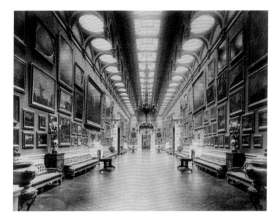

13
James Roberts (*c*.1800–67), *Prince Albert's Dressing Room, Osborne House*, 1851, pencil, watercolour, bodycolour and gum arabic, 24.3 × 36.8 cm, RCIN 926224

14
W. & D. Downey, *The Picture Gallery, Buckingham Palace*, 1910, platinum print, 22.2 × 28.1 cm, RCIN 2104521

reference to his depiction in one of the fireplace medallions. This separation of paintings by school was promoted in the 1850s by Prince Albert and Waagen, whose views on gallery arrangements were influential at the time. In an 1853 article in the *Art Journal* Waagen particularly highlighted the importance of separating the Italian and Northern schools, and this thinking probably guided their strict demarcation in the Picture Gallery.

However, this orderliness did not extend to the actual arrangement of the pictures. Louis Haghe's watercolour (see Fig. 11) and later photographs from the 1870s (Fig. 12) show inconsistent gaps between pictures, small pictures hung high up and others floating adrift from any tier. This approach is not representative of Prince Albert's picture displays elsewhere. Paintings in other residences were hung in an ordered way, particularly at Osborne House on the Isle of Wight. In his Dressing Room there he arranged the treasured early Italian pictures very precisely (Fig. 13). Presumably the intimate nature of the space and Prince Albert's interest in the paintings informed the more careful display,

reinforcing the view that personal preference directed his attention away from the hang in the Picture Gallery at Buckingham Palace.

Its arrangement changed very little between 1852 and Queen Victoria's death in 1901. In 1898, the Surveyor of the Queen's Pictures, Sir J.C. Robinson, suggested that the paintings were suffering under old varnish and pollution from the gas-lit chandeliers, and that a re-arrangement was required. Eventually the Queen approved the cleaning, glazing and relighting of pictures, but, in response to the prospect of a rehang, her reply was that 'The pictures at Windsor and Buckingham Palace were settled by the Prince Consort, and the Queen desires that there shall be no change'. When King Edward VII acceded to the throne in 1901, much work was thus required to conserve the paintings and refresh the hang. Sir Lionel Cust was appointed Surveyor and was responsible for the rearrangement, with frequent input from the King himself. In 1885, 184 pictures adorned the walls, but by 1910, 207 pictures were hanging (Fig. 14). This denser hang

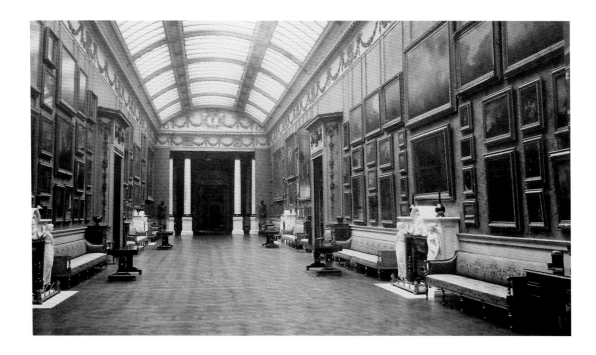

15

Sir Alexander Nelson Hood (1854–1937), *The Picture Gallery, Buckingham Palace*, 1914, gelatin silver print, 29.0 × 38.7 cm, RCIN 2947423

was typical of Victorian galleries. An assortment of pictures had been added, including works by the Master of the Johnson Magdalen, Godfrey Kneller, Giovanni Baglione and Sebastiano Ricci. The last two additions marked the gradual reintroduction of Italian school pictures to the Gallery, which has continued in modern hangs.

During the reign of King George V and Queen Mary the Picture Gallery underwent structural changes. Of particular note was the removal of Nash's beautiful, but leaky, roof and its replacement with Aston Webb's more practical, but less interesting, depressed barrel-vault design. Further amendments were made to sculptural details. A frieze around the top of the Gallery was

installed and the scagliola doorcases were replaced with wooden examples, adorned with Grinling Gibbons-inspired carvings. Probably in reaction to his father's taste, the King 'expressed His dislike of Gold Walls' and instead opted for green silk damask for the Gallery, inspired by an example at Welbeck Abbey. Cust and Sir Charles Holroyd, of the National Gallery, made some changes to the hang, but it remained dense (Fig. 15). Small pictures hung in 'drops', one on top of the other on either side of the fireplaces, heightened the symmetrical effect.

In 1947 the Gallery underwent a drastic rehang (Fig. 16). A single tier of paintings was introduced, with the removal of many of the Dutch cabinet pictures to the Royal Closet, a small drawing-room on the west side of the palace. Large works that had formerly adorned the walls of Buckingham House were reintroduced, including van Dyck's painting

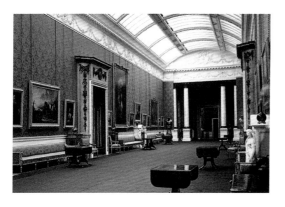

16
Display in the Picture Gallery, Buckingham Palace, c.1947

17
Display in the Picture Gallery, Buckingham Palace, 2018

of *Charles I with M. de St Antoine*. Although it provided an opportunity for close looking, the low hang highlighted the high walls and resulting empty space. By the 1950s, the display had been expanded and refreshed, structured in symmetrical groupings around the large portraits, including *'The Greate Peece'* and Daniel Mytens' *Charles I and Henrietta Maria Departing for the Chase*.

The colour scheme of the Picture Gallery was changed to coral pink in 1976, and Oliver Millar, Surveyor of The Queen's Pictures, built on the symmetrical and evenly spaced hang, with small cabinet pictures arranged on the lower tier. The current arrangement (Fig. 17) has developed this practice, and the resulting hang emulates the original Buckingham House displays, grouped symmetrically by school and loosely by genre, aided by George IV's magnificent Dutch and Flemish acquisitions. Some reconstruction frames have been introduced for Dutch paintings, which benefit from a simpler dark wooden frame.

When George III acquired the collection of Consul Smith in 1762, a report in the *Public Advertiser* announced that the pictures would be

hung at Buckingham House and 'Tickets will be given to the Nobility and Gentry to admit them to see it'. No evidence of this has yet been uncovered, but George IV enabled a broader public to see Old Master paintings from the collection by lending to the British Institution from 1815 onwards. This tradition continued throughout the reigns of William IV and Queen Victoria, the latter of whom opened the Picture Gallery to members of the public for the first time, through an order secured from the Lord Chamberlain when the Royal Family was not in residence. Catalogues of the Gallery were produced and sold publicly, which further promoted an awareness and understanding of the Royal Collection. Today the Picture Gallery is opened to the public every summer. The picturesque views of St James's Park that the Duke of Buckingham admired from his closet are no longer visible from the Gallery, but the presence of magnificent works continues the long and rich history of the display of Old Master paintings in the palace, and pays tribute to the monarchs who first collected and arranged them.

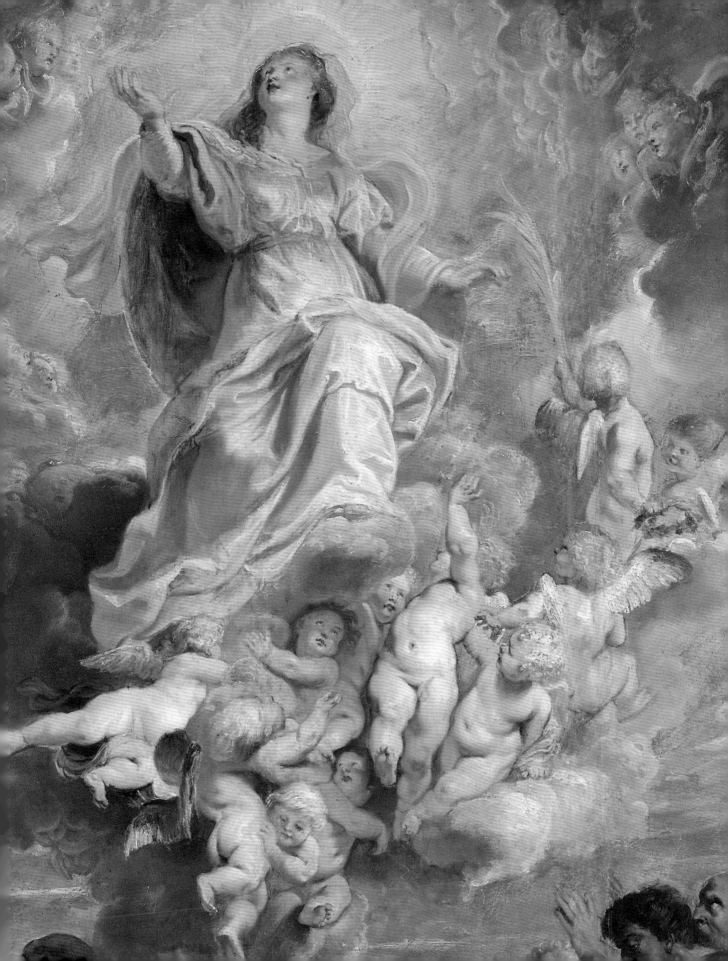

Looking at Old Master Paintings

Desmond Shawe-Taylor

There are various ways of looking at the Old Masters. A catalogue of this kind might normally discuss the works in relation to their creator's career, or perhaps to the artistic theory of the age in which they were made. When discussing the Royal Collection it is often the taste of the monarch who acquired a work that is explored and the history of its display (see pp. 7–19). Most paintings in this catalogue are securely attributed and dated, and, while touching on these matters, we (the curators) also seek to engage with a different, perhaps riskier and more subjective line of questioning. Here we are not asking when these works were painted and by whom, but rather, why should we concern ourselves with them at all?

This catalogue discusses 'Masterpieces' produced by 'Old Masters'; neither term is especially helpful and to some they are off-putting. They are used here (for want of an easy alternative) to mean 'esteemed paintings produced by artists (of both gender) working before 1800'. The fact that the Old Masters here are all men and all European

Peter Paul Rubens, *Assumption of the Virgin*, detail of cat. 24

reflects the history of display at Buckingham Palace rather than the composition of the collection as a whole. But what made these paintings esteemed? Should they continue to be and if so why? What do they have to offer a modern viewer?

It would be reassuring if the answer to this question corresponded to some extent with what the artists thought they were trying to achieve, and the royal purchasers thought they were trying to acquire. The works in this catalogue were created between 1510 and 1740; they were acquired between 1620 and 1830. Comfortably within these time spans, in 1708, Roger de Piles published his *Cours de peinture par principes*, which included a *Balance des peintres* (we would call it a 'Balanced Score-Card'), introducing a refreshing spirit of accountancy to the discussion of painting. In it he scored some 50 painters against four 'Key Performance Indicators' – *Composition*, *Drawing*, *Colour* and *Expression*. The outright winner was Rubens, with scores of 18, 13, 17 and 17 out of a possible 18 in each category. If we were to undertake a similar exercise, what headings might we come up with? De Piles chose his four with consideration of the French Academy

(even if in partial opposition to it); with no such adversary we might shift the balance slightly. Our first heading should be *Realism* – the ability to imitate or suggest the world around us. This quality was admired in painting from the time of Giorgio Vasari and was regarded as self-evident by de Piles and his contemporaries. The next quality is an adaptation of de Piles's 'Colour' but might be better expressed as the artist's *Use of Materials*, their communication of the sensual qualities of paint and its handling. The third quality conflates de Piles's 'Composition' and 'Drawing' into the single word *Design* – the artist's organising, embellishing and pattern-making principle. De Piles's final quality, *Expression*, stands the test of time, though he would have thought it applied primarily if not exclusively to narrative painting. It should be extended to include the expressive qualities of portraiture, landscape or even still life. If one wished to sum up these four categories, we might say that at its best Old Master painting can be realistic, sensual, beautiful and moving.

To some extent *Realism* (our first KPI) is about accuracy – things, like visual geometry, which can be right or wrong. There are accomplished examples of illusionism – the false frame in Rembrandt's *Agatha Bas*, through which the sitter looks and very slightly extends (cat. 38); the false windows in the work of Dou and Jan Steen (cats 48 and 53); the perfect perspective in Pieter de Hooch and Johannes Vermeer (cats 51 and 52). In the latter case the artist has included a glimpse of himself at his easel in the mirror, to demonstrate how perfectly truthful the image is. Realism is also about *extent* – it is a measure not just of art's cleverness but of its power. In most Old Master painting there is a more-is-more copiousness, designed to excite wonder as well as recognition. If an artist can paint a little baby angel, why not then, like Rubens (cat. 24), paint 12 of them, in every possible position seen from every possible angle, and then merge them with the clouds so that this one cluster seems to be replicated *ad infinitum*? Rubens creates a miraculous world; the reality of David Teniers' *Kermis on St George's Day* (cat. 42) is more down to earth. But the same principle applies: we might get the point of his peasant dance from a handful of figures, but why not paint 50? If depicting a cottage (cat. 56), a farmhouse (cat. 43), a kitchen (cat. 47), a shop (cat. 48) or a camp (cat. 41) it is the same – the more people, things or surfaces the merrier. This applies to acreage in a landscape – distance lends enchantment to the view, but it also expresses the artist's power to bring into being (on a small flat surface) an entire province (cats 25 and 26). Detail is also an expression of copiousness. Samuel Johnson famously wrote that the poet does not 'number the streaks of the tulip, or describe the different shades of the verdure of the forest'. Artists do. There is plenty of what might be called 'high resolution' in the works of Dou and his followers – streaks are numbered, and shades differentiated. As in the digital world, high resolution means a quantity of information and is a manifestation of power.

Richness of material also demonstrates the painter's alchemic power to turn base matter into gold. Expensive things are generally more brightly coloured, finely grained or patterned, more transparent or reflective than their cheap equivalents. All these things make them finer, shinier, denser, and more difficult to paint. It is often observed that clothes in the sixteenth and seventeenth centuries were typically more expensive than paintings. Artists became inspired forgers of lace, ruffs and jewellery (see cats 34, 35, 38 and 46). Most of the examples cited above are by Dutch

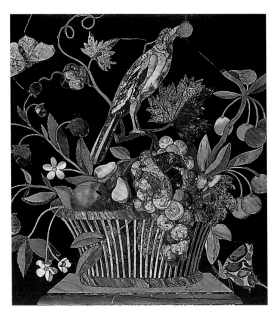

18
Florence, *Pietra dura* panel, *c.*1625, set into Adam
Weisweiler (1744–1820) *commode*, 1785–90, RCIN 2593

Johannes Vermeer, '*The Music Lesson*', detail of cat. 52

or Flemish artists, who were widely criticised for overdoing realism. Italian art was always believed to have a higher goal than the mere copying of appearances; this does not prevent it from appreciating these qualities of richness and copiousness. There is plenty going on in Lorenzo Lotto's *Andrea Odoni* (cat. 3), especially in the corners – the part of a portrait which normally fades to nothing. Parmigianino creates costume jewellery of great finesse (cat. 7). Rich stuffs and fine textures play an essential part in Cristofano Allori's *Judith* (cat. 9). Canaletto's *Ascension Day* (cat. 23) is a perfect example of what might be called the aspirational power of painting, transporting the viewer to a famous beauty spot, at its most festive, through a high-resolution technique doing justice to the brightest colours of fabric and the finest details of architecture and craftsmanship.

It hardly needs pointing out that Dou and Canaletto do not manipulate digital information; they apply oil paint to a flat surface. What does their *Use of Materials* add to our enjoyment of their work? This issue is most easily understood when the material is precious of itself. In a *pietra dura* panel (Fig. 18) sections of hardstone, with shifting colours and mottled patterns, are carefully arranged to make a bird or flower. The stone is beautiful of itself before we admire the ingenuity with which it is selected and the skill with which it is cut and inset. There are direct analogies with painting. Ultramarine is made of ground lapis lazuli, a precious stone, and is often used in blocks, as in Titian's *Madonna and Child* (cat. 2), where the purity and the expense of its blue can be appreciated. Vermeer uses colour of heightened intensity (again with profligate use of ultramarine)

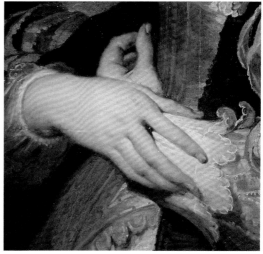

Lorenzo Lotto, *Andrea Odoni*, detail of cat. 3

Peter Paul Rubens, *Portrait of a Woman*, detail of cat. 29

and arranges his surface as if a *pietra dura* panel of precious materials (cat. 52). Conversely, painters are as interested in cheap materials used in an apparently careless way as they are in the careful arrangement of precious colours. Leonardo da Vinci advised painters to 'look at walls splashed with a number of stains, or stones of various mixed colours. If you have to invent some scene, you can see there resemblances to a number of landscapes'. Stained walls are as inspiring as coloured marbles. The equivalent in painting occurs in the under-layers – often mixtures of earth colours, browns and greys, scrubbed on thinly and loosely. Teniers' 'The Stolen Kiss' (cat. 43) or Adriaen van Ostade's *Cottage* (cat. 56) both have an unfinished air, espe-cially at the margins, with these greyish-brown underlayers showing through. A similar effect is seen to a lesser extent in most of the works in this catalogue, seeming like the raw clay of painting waiting to be formed. As with *pietra dura*, we enjoy the transformation, the experience of something

coming into being, something simultaneously experienced as *paint* and as *painted thing*. This is partly a matter of finish. The background of Hals' portrait of an unknown man (cat. 34) looks like an artist's canvas waiting to be painted and yet the work is never described as unfinished. Viewers are naturally generous: if they have been 'let in on' the process of a painting – as in portraits by Hals or van Dyck (cat. 32) – they are happy to finish it off for themselves. In cases like this we are reminded that the material of painting is flat, while its sub-ject is generally made up of three-dimensional volumes in space. Common sense would tell us to suppress the flatness at all cost: the Old Masters – again in these portraits (cats 32 and 34) or in the landscapes of Teniers (cat. 40) and Willem van de Velde (cats 61 and 62) – teach us to flaunt it.

The handling of the brush is a central part of an artist's use of materials. The easiest to appreciate in this respect are the *gesturers*, like Hendrick ter Brugghen (cat. 33), Hals (cat. 34), Nicolaes Berchem

Rembrandt van Rijn, '*The Shipbuilder and his Wife*', detail of cat. 35

Frans Hals, *Portrait of a Man*, detail of cat. 34

(cat. 65) and Canaletto (cats 19–22), who apply thick paint-shapes with a character of their own, which morph into expressive figures or features, often seen in motion. But there are also those, like Rubens and van Dyck, who *draw* with a paint brush (cats 28, 29 and 31); those like Rembrandt, who *sculpt* in thick oil paint (cats 35 and 38); or those, like Lotto or Parmigianino, who *suggest* with a soft touch often called 'feathery' to convey shadow, motion or any other form of visual uncertainty (cats 3 and 7).

Throughout history people have done their hair in different ways, agreeing on one thing only – that hair needs to be 'done'. In the same way it was generally accepted that Art should run a comb through Nature. This is the principle of *Design*. A visit to the websites of almost any major museum will reveal a range of design-systems at work, whether in Chinese porcelain, Mughal miniatures or Byzantine mosaics, each with their own aesthetic consistency while seeming to bear

little relation to each other. Old Master painting is dominated by one aesthetic system, learned from the sculpture of classical antiquity and the paintings of Raphael, and taught in every academy in Europe. Guido Reni's *Cleopatra* (cat. 11) shows what it looks like. With no incidental details in the background, a figure seems to hover somewhere between sculpture and flesh and blood; her every part has a satisfying rhythm, whether the folds of her drapery or the polished spheres from which her anatomy seems to be formed. You can see or guess that the figure is based upon a preparatory drawing. Drawing at this time had a special prestige as the thinking part of art, through which the artist might learn to recognise and study the ideal beauty of the Antique and re-create it. We see this idealising principle at work in paintings by Italian artists or those, like Rubens and van Dyck, who adopted their values. Parmigianino's *Pallas Athene* (cat. 7) has a refinement and systematisation of feature that would have suggested to its original

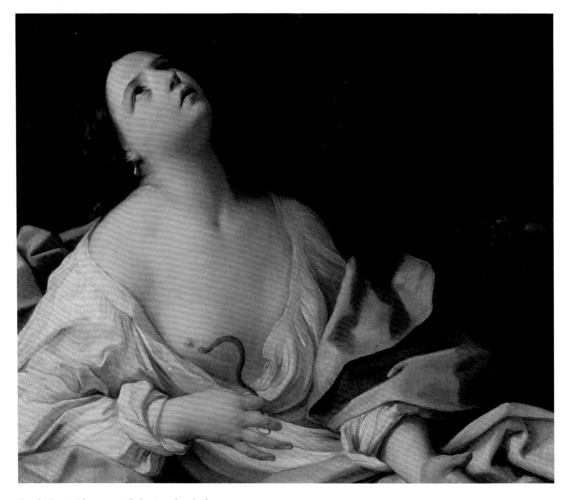

Guido Reni, *Cleopatra with the Asp*, detail of cat. 11

audience the notion of otherworldly beauty. Van Dyck's *Christ Healing the Paralytic* (cat. 30) expresses the difference between human suffering and divine mercy by selecting different examples from the same exalted tradition – the Christ from Raphael's tapestry cartoons and the paralytic man from the Antique sculpture called the *Fisherman* (Borghese Gallery, Rome), then described as the 'Dying Seneca'. Even wretchedness is dignified by design.

The difficulty with this quality lies in its contemporary relevance. Most viewers today presented with van Dyck's *Thomas Killigrew* (cat. 32) and Rembrandt's *'The Shipbuilder and his Wife'* (cat. 35) would choose the latter precisely because of its absence of design in the sense understood above. We find the elegant sweeping lines of van Dyck's portrait mannered in comparison to Rembrandt's clumsy volumes of individual humanity. The comparison between

Rubens' beguiling *Portrait of a Woman* (cat. 29) and Rembrandt's confrontational *Agatha Bas* (cat. 38) would yield a similar result. We value Rembrandt's jolt of truth. De Piles gave Rembrandt a derisory 6 for 'Drawing' (in comparison to 13, 15 and 10 respectively for Reni, Parmigianino and van Dyck). We would say that he has missed the point entirely.

Our difficulty lies in describing the element of design, what might be called the aesthetic, of a Rembrandt portrait, or any other work that lies outside the dominant academic tradition. It is easy to fall into the prejudices of the age according to which there is a choice of two, between the Ideal (beautiful and classical) and the Real (ugly and Dutch). Any artist's style is to some extent an interpretation and embellishment of the world. It usually owes something to predecessors, however much it is adapted, and offers something new to successors. With almost every painting in this catalogue it is possible to identify an influence, which enhances rather than diminishes its stature. The most influential artist outside the classical tradition was Titian, whose works inspired those of van Dyck, Hals, Rubens and Rembrandt. Pieter Bruegel the Elder was another significant 'alternative' artist who established an enduring tradition of landscape painting and the depiction of peasant life, seen in the landscapes of Rubens and the genre paintings of Teniers, Adriaen van Ostade and Steen. Similarly, many painters here had a formative impact on some of the greatest and most original painters of the nineteenth century: Turner, Constable, Delacroix, Manet and the Impressionists.

The study of subject matter in art is called iconography; it addresses questions of *Expression*, but its focus is the identification of textual sources and symbols. There is little equivalent in the enjoyment of old paintings of that receptiveness which would allow a theatre audience to understand an Elizabethan or Restoration play without programme notes. Viewers are as likely to be as intuitive as hearers; images, like words, operate by suggestion and nuance. But somehow the question 'what is happening in this picture?' seems one more likely to be addressed to a child than a serious gallery-goer. It was not ever thus. In the seventeenth century there was a considerable literature teaching how to read history paintings – left to right, action by action, expression by expression. We can see how this might work for van Dyck's *Christ Healing the Paralytic* (cat. 30): two sick men to the left have expressions of ignorant astonishment; the paralytic one of faith and supplication; Christ expresses mercy and instruction; the right-hand Apostle betrays pride and uncomprehending disapproval. The static symmetry of a painting allows us to meditate upon these different reactions – balancing, with Christ on the fulcrum, the dark and the light, the sick and the sound, the humble and the proud.

There was no such literature at this date for portraiture or genre painting, but we should be able to try something similar. Narrative portraits (often landscape format) can be surprisingly explicit. Andrea Odoni converses with the viewer, in an engaging but also perhaps slightly overbearing way (cat. 3). Thomas Killigrew exhibits the lassitude of melancholy – we know this because he holds the design for his wife's tomb (cat. 32). Jan Rijcksen is interrupted by a message brought in by his flustered and anxious wife, Griet Jans (cat. 35); we can reasonably guess that he thinks it less urgent than she does. The family of Jan-Baptista Anthoine (cat. 46) appears to be a model of prosperity, decorum, affection, health, vigour and cheerfulness.

Jan Steen, *Interior of a Tavern, with Cardplayers and a Violin Player*, detail of cat. 54

But what of those without such obvious attributes? Responding to a painting must be in part subjective: this allows us to observe that Jacopo Sannazaro is scholarly and pensive (cat. 1), Vincenzo Avogadro pious and haunted (cat. 10), Hals' unknown sitter swaggering and cheerful (cat. 34) and Agatha Bas reflective and steadfast (cat. 38). This subjectivity may be sense-checked by historical probability. The apparent burden, almost torment, of Avogadro's faith, for example, can be matched in contemporary poems by John Donne. This allows us to ask what shared sentiments might have been familiar to a Mantuan cleric. A similar process of cultural analogy might

also apply to genre painting. Four of the characters around the table to the right of Steen's violin player in *Interior of a Tavern* (cat. 54) might be lifted from Shakespeare's *Twelfth Night*: from left to right there seems to be a Maria (in the blue jacket), a Toby Belch, an Andrew Aguecheek and a Feste (standing in front of the lute). These four stock types (or something like them) may have been as familiar in Leiden as in London. What is certain is that they *are* comic characters and we need to 'get' them, like a joke. Reading intuitively for character and situation *may* lead to a misunderstanding of the artist's intention; avoiding doing so, in the interests of scholarly objectivity, *guarantees* a misunderstanding of the artist's intention.

Landscape can be as expressive as figure painting: Gaspard Dughet's *Seascape with Jonah and the Whale* (cat. 18) conveys divine wrath through the storm, the lightning and the monstrous fish, but also more generally though the darkness, the precipitous rocks and the terrifying confusion of sky, sea and land. Claude's *Harbour Scene* (cat. 15) expresses calm through a process of 'winding down': the sun setting, the men hauling the final loads to shore and sleeping; the choppiness of the sea wearing itself out on the shore. Claude's *View of the Campagna from Tivoli* (cat. 16) depicts what were believed to be the ruins of the Villa of Maecenas, where the Antique patron might have entertained Horace and Virgil. Contemporaries must have found in Claude's landscape the same capacity to resonate with human moods as the pastoral passages in their poetry (and that of their subsequent admirers). In this case that mood was presumably an elegiac reflection on the passing of the day and of civilisations.

It will be clear by now that our last three qualities – use of materials, design and expression

– must interact with the first, realism. It is no good creating an interesting blob of paint if it doesn't look like a man, or accentuating the flatness of the canvas if it doesn't also express great space or volume. In the range of design-systems (academically approved and alternative) the difference between a derivative mannerism and a transformative re-creation lies in the power of the resemblance. The effectiveness of expression in art – as in literature – depends upon its verisimilitude. Here we see how wrong it is to fall into the common assumption that artists copy ('like a photograph') and writers invent. An artist may copy a tree but must evoke a conversation; a novelist may copy a conversation overheard on a train but must evoke a tree. In practice, of course, both are inventing and evoking all the time. However, while there are scores of rhetorical devices to help poets create and justify their evocations, there is a limited vocabulary for the equivalent in painting. For example, the precise geometric perspective of Claude's *Harbour Scene* (cat. 15) allows us to calculate from exactly how far away the painting should be viewed, its frame like that of a window. But Claude does not wish to suggest that we are peering through a window, any more than Shakespeare wishes to present the 'vasty fields of France' in a little cockpit seen over the backs of many heads (*Henry V*, Act I, Prologue). Claude wishes to put us in the harbour, hearing the waves, smelling the sea and feeling the last warmth of the day. But how? In part this is 'aerial perspective' – the artist's ability to record the behaviour of light in space and in relation to viewpoint. At dusk looking towards the sun the air is misty and yellow; looking away it is clear and blue. Claude shows both and the gradations in between, from the golden veil round the sun to the sharply lit section of entablature against

Parmigianino, *Pallas Athene*, detail of cat. 7

the blue sky to the upper right. This range implies a far wider angle of vision than the geometrical perspective described above. In this sense we are in the harbour. This effect also depends upon viewers being reminded of something they have noticed in nature, however subconsciously. Thus stimulated, the viewer's memory supplies the sound, smell and sensation of the scene. This is called imagination. An artist, like a poet, must 'on your imaginary forces work' (Shakespeare, *Henry V*). Painters present a wealth of information (Claude's *Harbour*

is dense with incident and high in resolution), but painting is not a matter of fact. As was often stated at the time, painting is like poetry. The difficulty lies in recognising its figures of speech.

We will never find equivalents for every rhetorical device, but an artist's creative licence might be more broadly defined under the two headings of exaggeration and comparison. Exaggeration may be seen in the dramatic contrasts of light and dark in Dughet's storm (cat. 18) and in the modelling of Jacob's face (cat. 13). It may be seen

in the intense primary colours in de Hooch and Vermeer which convey a suggestion of bright light (cats 50 and 52). Simplification – a form of exaggeration – occurs whenever some part of an image is skimped in order to enhance another, as occurs in the backgrounds of most portraits (cats 6 and 34). Exaggerated simplification can also summarise a scene, giving it a one-word impact: Teniers' *Fishermen on the Sea Shore* (cat. 40) is grey – the sky, the sea and the shore; Claude's *View of the Campagna from Tivoli* (cat. 16) is dusky (critics might even say dull), exhibiting an extraordinary uniformity of tone and colour.

Comparison is the lifeblood of art (to use a metaphor illustrating the principle). The sculptural fragments in Lotto's portrait (cat. 3) resemble living beings, relating to each other with a range of witty collisions and incongruities. Parmigianino's *Pallas Athene* (cat. 7) has hair as bright and finely spun as the gold of her breastplate. Reni's *Cleopatra* (cat. 11) seems to be turning into marble as her colour drains away, in a metaphor for death. In Rubens' oil sketch, the Virgin (cat. 24) becomes a sun and clouds as she ascends, while in *Summer* the flocks (cat. 26) melt into a river of plenty flowing into the valley. Figures also rhyme: the solicitude of the angel and the tender attention of the Virgin in Titian's *Madonna and Child* (cat. 2) are expressed through gestures that echo each other.

The most complex example of creative licence is Rembrandt's use of light, which he endows with properties not recognised by Christiaan Huygens or Isaac Newton. Heat and light are related, but heat may be transferred by conduction and convection as well as radiation. Rembrandt's light behaves like heat, spreading in pools, usually expressing human warmth and seeming to struggle against a palpable darkness. The rising sun in *Christ and St Mary Magdalen* (cat. 37) makes a circle with Christ at its margin, echoing the words of St John's Gospel (1:5): 'the light shineth in darkness; and the darkness comprehended it not'. The metaphor is stronger here precisely because this light has made only modest progress in comprehending the darkness. The spiritual equivalent of this darkness – fear and doubt – can be seen in the Magdalen's only half-lit face. Light makes pools in Rembrandt's portraits, usually centred on the head or breast, in a spiritual equivalent of thermal imaging. Rembrandt's work fluctuates between extremes of literal and metaphorical: *Agatha Bas* (cat. 38) has a reality that could be attested by the touch; at the same time her hair is sinking into an incomprehensible darkness.

Agatha Bas is certainly realistic, sensual, beautiful and moving. Not all works in this catalogue can live up to this standard. They do without exception exhibit remarkable realism, which was something of an entry-level qualification at this date, but only some deserve a mention under one or two other headings. Unlike de Piles, we are not really keeping score. Even his *Balance des peintres* was surely intended to be more provocative than definitive. Viewers will want to make up their own minds.

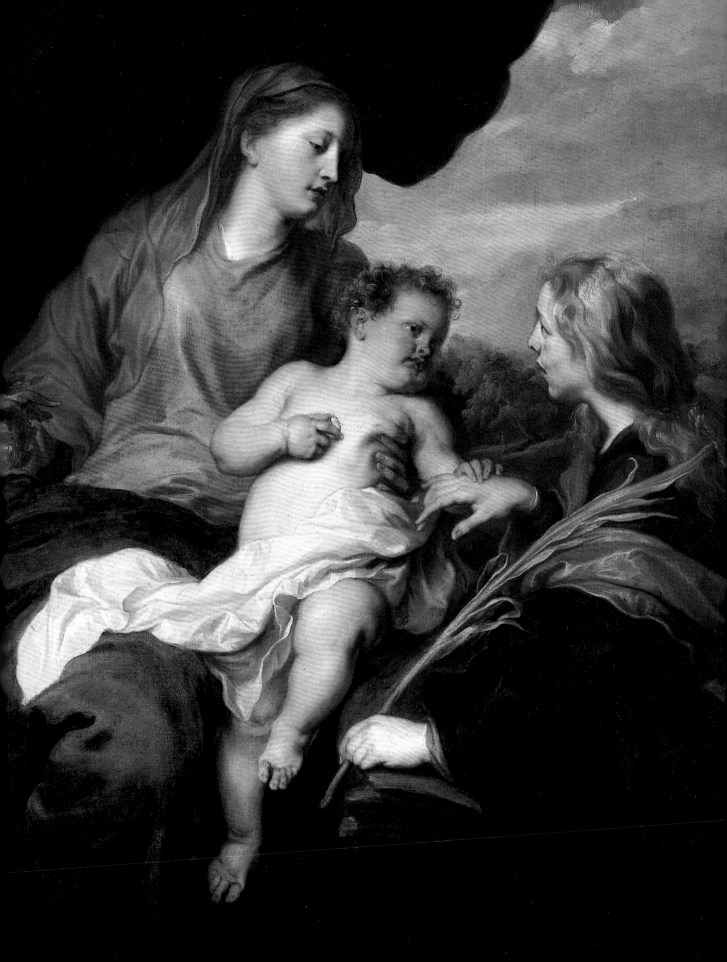

THE PAINTINGS

1

Titian
(c.1488–1576)

Portrait of Jacopo Sannazaro

*c.*1514
Oil on canvas, 85.7 × 72.7 cm
RCIN 407190

Presented to Charles II in 1660 by the States of Holland and West Friesland as part of the 'Dutch Gift', a group of paintings, furniture and sculpture given to the King upon his restoration to the throne

The scholar who gazes out of the picture is thought to be the Neapolitan humanist and poet Jacopo Sannazaro (1458–1530). He marks a page in a book with his finger, a pose often repeated in portraits of intellectuals, intended to accentuate their learning and contemplation. His long hair, centre parting, hint of a moustache and sober clothes were characteristic of male fashions in Venice at the time, although Sannazaro lived and worked in Naples for most of his life. His best-known work, *Arcadia*, was published in Venice in 1502. The poem revived the pastoral tradition in literature, in turn influencing the nostalgic mood of landscape painting by Venetian artists including Titian and Giorgione.

Titian's monochromatic treatment of the background and costume draws attention to where there is colour. Our eye travels from the red book cover to Sannazaro's illuminated face, where flesh tones construct his eyes, nose, cheeks and mouth. Colour thus structures the design, connecting the source of his contemplation (the book) to the result (an enlightened mind).

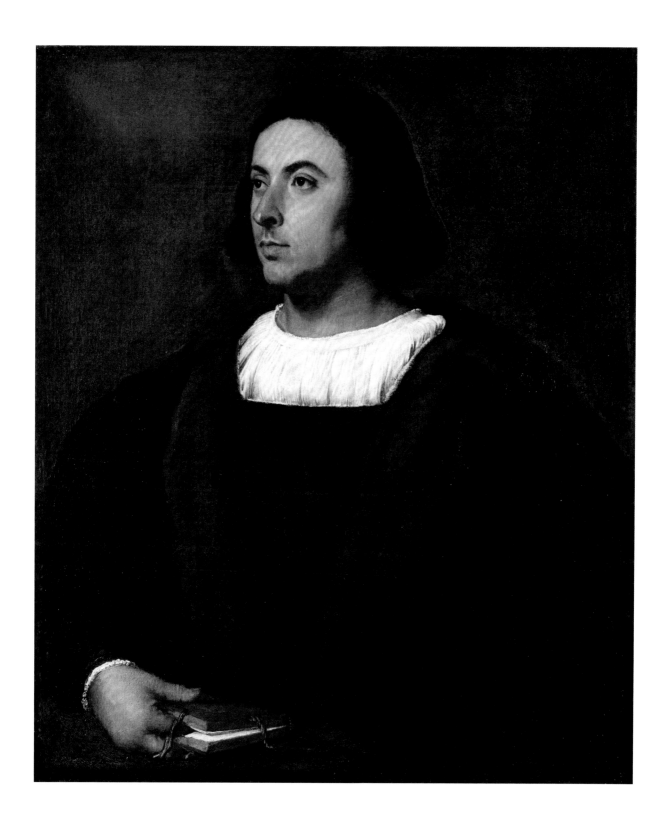

2

Titian
(c.1488–1576) and Workshop

Madonna and Child in a Landscape with Tobias and the Angel

*c.*1537
Oil on panel, 85.2 × 120.3 cm
RCIN 402863

Presented to Charles II in 1660 by the States of Holland and West Friesland (see cat. 1)

In this tender depiction of mother and infant set against the Dolomite Mountains, the Virgin and Christ Child gather flowers next to a stream. The Virgin picks a campanula, while Christ holds a rose, symbolising his Passion and the Virgin's purity.

Four related depictions of the Virgin and Child by Titian and his workshop exist. Unique to this version is the presence of Tobias and the Angel on a journey in the landscape beyond. The Angel embraces Tobias, echoing the close relationship between the Virgin and Child. Titian's insightful design emphasises the bond between mother and baby. The contours of Christ's body are out of focus, and the wriggling of his limbs is almost palpable. He shows his mother the roses he has picked, and she looks down affectionately and attentively, exuding a warmth that we imagine exists between a divine mother and child.

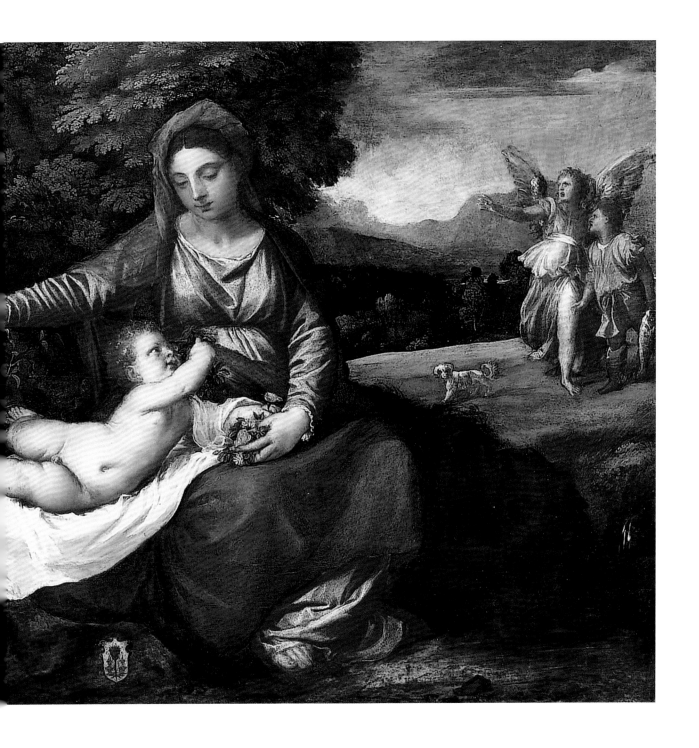

3

Lorenzo Lotto
(c.1480–1556)

Portrait of Andrea Odoni

Signed and dated 1527
Oil on canvas, 104.3 × 116.8 cm
RCIN 405776

Presented to Charles II in 1660 by the States of Holland and West Friesland (see cat. 1)

Lotto's portrait conveys the ambition of both artist and patron. Recently returned to Venice from Bergamo, the artist presumably painted this powerful portrait of Andrea Odoni (1488–1545) to challenge Titian's dominance of the field. Odoni was a wealthy member of the Venetian merchant class, open to the commissioning of portraiture outside the traditional canon. The resulting painting, arguably the first modern portrait of a collector surrounded by their treasures, marked a transitional moment in the history of portraiture.

The wide format, previously used by Lotto only for double portraits, is here adapted to highlight the breadth of Odoni's collection. It also accentuates the presence of the sitter, accommodating his billowing gown, probably lined with wolf-skin. This voluminous garment allows the artist to experiment with textures, contrasting the richness of the black silk with the delicacy of the fur trim. The sitter's dynamic pose and arresting gaze invite the viewer into the conversation, redefining portraiture as an interactive genre and collecting as a shared activity.

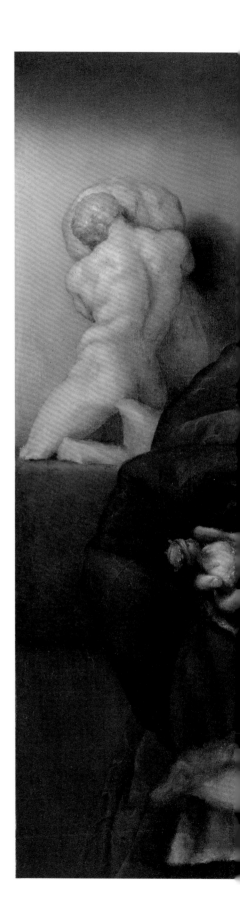

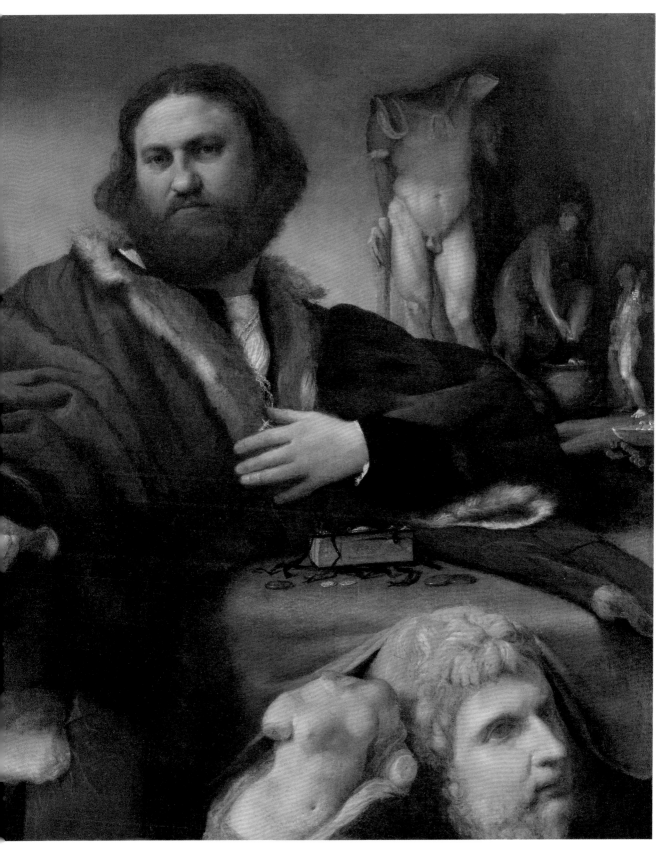

4

Andrea del Sarto
(1486–1530)

Portrait of a Woman
in Yellow

1529–30
Oil on panel, 64.3 × 50.1 cm
RCIN 404427

First recorded at Windsor Castle during the nineteenth century

It is possible that del Sarto left this picture unfinished because of his death from the plague in 1530. The unidentified sitter wears a yellow dress and white shirt with the hint of a green headdress. Del Sarto models her face by revealing one side in strong light, as the other recedes into the dark background. The simplicity of the design and use of colour harmonise with her enigmatic expression to create an air of impassive monumentality.

The picture is arguably more powerful in this unfinished state. Its energy comes from seeing paint brought to life. The poplar panel was prepared with a neutral ground (priming) colour, on top of which del Sarto's bold underdrawing is visible to the naked eye in the creases of the sitter's neck. Afterwards, he applied a thin, first layer of coloured paint, visible in the sleeve. The artist then used a broad brush to work up the shape of the fabric, indicating folds through adjustments made to the paint with his palm and fingers. The flesh is more finished, and del Sarto must have intended to return to the richly coloured costume later.

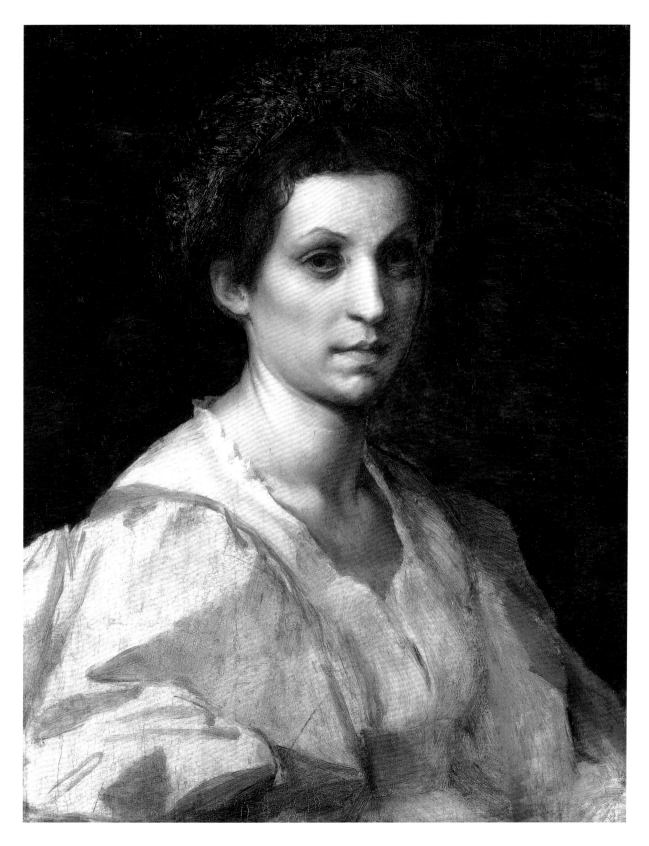

5

Pontormo
(1494–1556)

The Virgin and Child

c.1537
Oil on panel, 122.0 × 102.2 cm
RCIN 406117

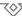

First recorded at Kensington Palace in 1818

There are more than 25 versions of this composition, also known as the *Madonna del Libro* ('Madonna of the Book'). It is unlikely that this painting is the original version, but its high quality and the presence of underdrawing and *pentimenti* (changes to the design) suggest it is by Pontormo himself.

At first, it appears to be a composition of two halves. In the foreground, Christ tucks himself close to the body of his sitting mother, who cradles him with one hand and holds an open book in the other. The figures in the background are harder to read. Presumably the nearest is an older Christ, who holds a basket of cherries (the fruit of paradise and a symbol of heaven) for his carpenter father, while the Virgin's mother, St Anne, stands under the arch, also holding a book. The theme of education thus brings the two figure groups together, as Christ learns from the books belonging to his mother and grandmother, and from the trade of his father. While there appears to be little continuity between the richly coloured cloth of the Virgin's dress and the muted tones Pontormo uses for the background figures, in fact, the contrast creates greater depth.

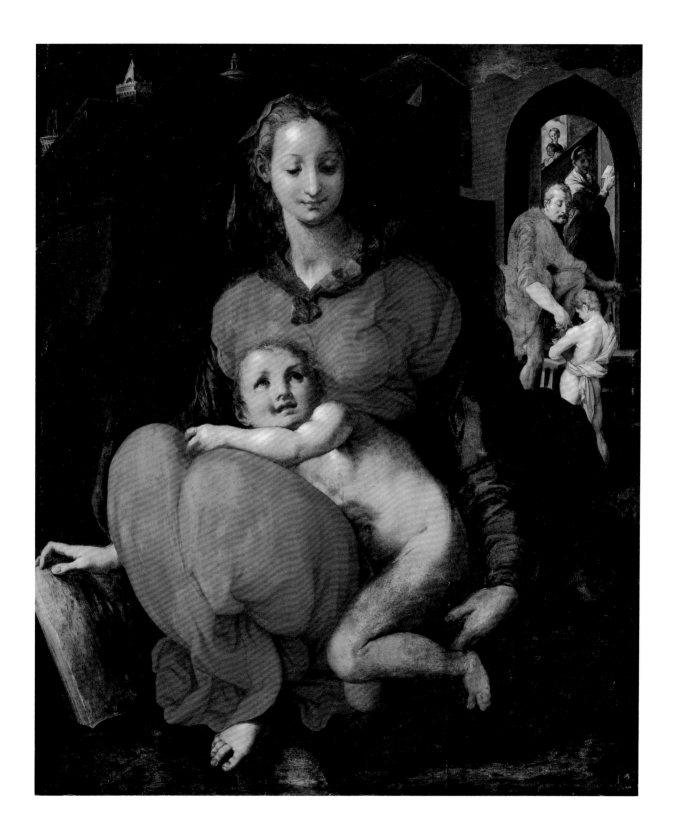

6

Parmigianino
(1503–1540)

Portrait of a Young
Nobleman

*c.*1531
Oil on panel, 98.5 × 82.4 cm
RCIN 406025

First recorded at Whitehall Palace in 1666

This unidentified young man twists towards the viewer, his arm stretched towards the table in a position that appears strained. The bulk of his cloak is at odds with his delicate facial features, and his unwavering, self-assured eye contact is somewhat disconcerting.

While the youth's face is carefully painted and highly finished, it contrasts with the loosely handled cloak and background, which in parts are very summarily treated. It has been suggested that the portrait is unfinished, but the variation must have been deliberate. The viewer is continually forced to return to the youth's pale face, whose lidded eyes and pursed lips appear dejected. The haunting atmosphere is compounded by Parmigianino's almost exclusively monochrome palette. The only real deviations are the sitter's rosy lips, which accentuate his adolescence, and the square of green in the frame behind him, which prompts the viewer to contemplate the mysterious surroundings and leaves us with more questions than answers.

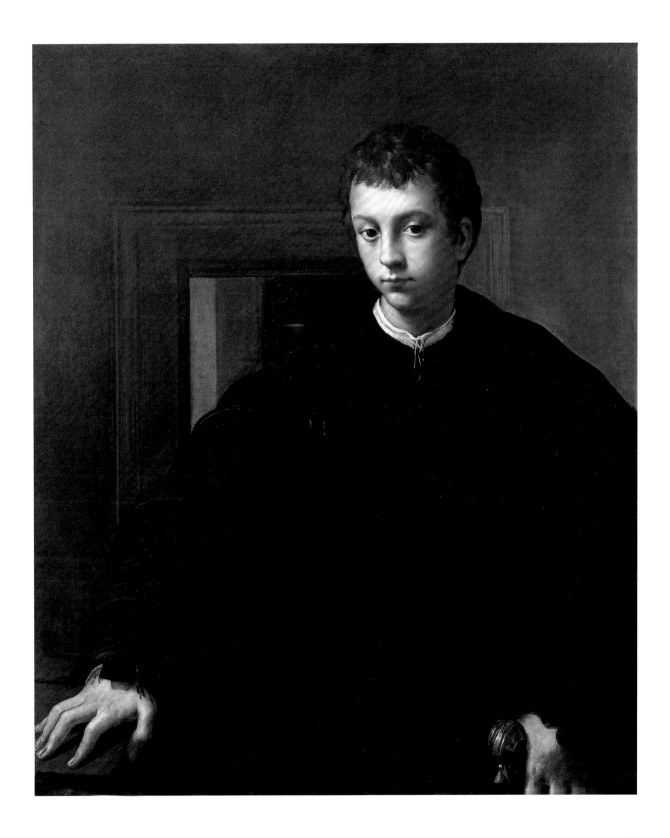

7

Parmigianino
(1503–1540)

Pallas Athene

*c.*1535
Oil on canvas, 64.0 × 45.4 cm
RCIN 405765

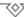

*Presented to Charles II in 1660 by the States of Holland and
West Friesland (see cat. 1)*

Pallas Athene was a warrior, the goddess of Wisdom and
patron of Athens. In the *Metamorphoses*, the Roman poet
Ovid describes Athene's 'golden' hair, which Parmigianino
brings to life here using a thin brush to pick out shimmering
strands. It is enough that he only describes certain threads
of hair this way – we are left with the impression of an all-
encompassing radiance. Although she wears a breastplate,
the artist omits most of her attributes of warfare, depicting
her without a spear, helmet or aegis with Gorgon's head.
On the plaque of her breastplate the inscription 'ATHENE'
identifies the goddess; above it the golden figure of Victory
flies over a city, presumably Athens. Her costume is set with
jewels, which glisten with white highlights. The detailed
frayed edge of her cloak wonderfully counteracts the rich-
ness of the jewels, reminding the viewer of the goddess's
other patronage of spinning and weaving.

Preparatory drawings for the plaque (formerly in the
Spector Collection, New York) and for the full composition
(The Morgan Library and Museum, New York) survive in
which the artist worked up the elegant and elongated pro-
portions and refined stylisation of Athene's features. The
resulting painting is a manifesto for a classically inspired
ideal of female beauty.

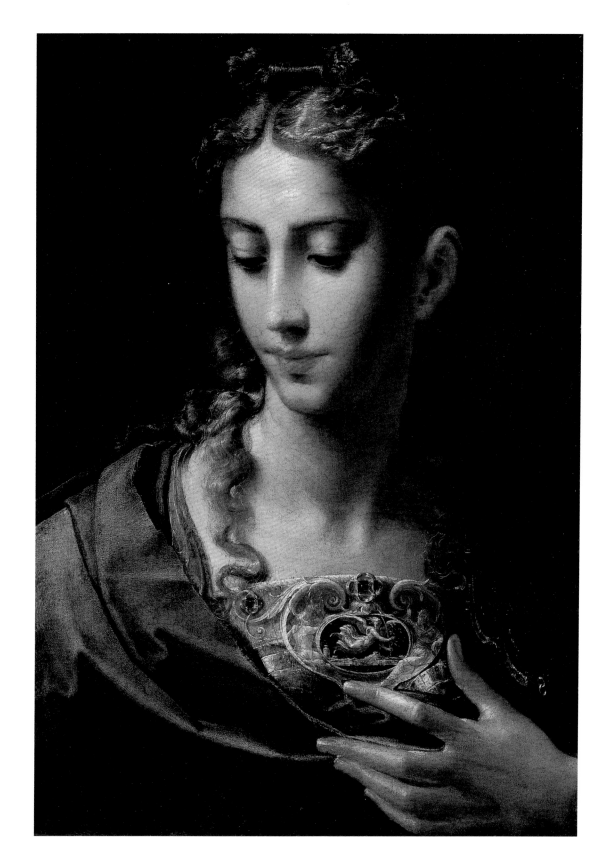

8

Leandro Bassano
(1557–1622)

Portrait of Tiziano Aspetti Holding a Statuette

1592–3
Oil on canvas, 88.0 × 67.2 cm
RCIN 405988

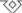

Acquired by George III in 1762 as part of the collection of Joseph Smith, British Consul in Venice

From the sitter's stylish dress, elegant pose and the sculpture in his hand, he could be mistaken for a collector, like Andrea Odoni (cat. 3), but the presence of a single object is more prevalent among depictions of sculptors, who would have been courting patrons with such portraits. Indeed, Bassano presents the Venetian sculptor Tiziano Aspetti (1559–1606), who in 1590 received a commission to create a large figure to adorn the door of the city's redesigned Public Mint (*Zecca*). In this portrait he proudly presents the wax model for his statue of Hercules, identified by his lion's skin and swinging club. Aspetti's unflinching eye contact puts the viewer in the role of a potential client: presumably the sculptor was hoping to capitalise on the prestigious *Zecca* commission.

Much like the model Aspetti holds, Bassano's portrait has a sculptural quality: controlled highlights and shadows carve the strong contours of his nose, cheeks and hands, influenced by the subtle tonal gradations in the portraiture of Titian and Jacopo Tintoretto. As in Titian's *Jacopo Sannazaro* (cat. 1), the modulated flesh tones of Aspetti's face and hands bring him to life, distinguishing him from the inert wax statue.

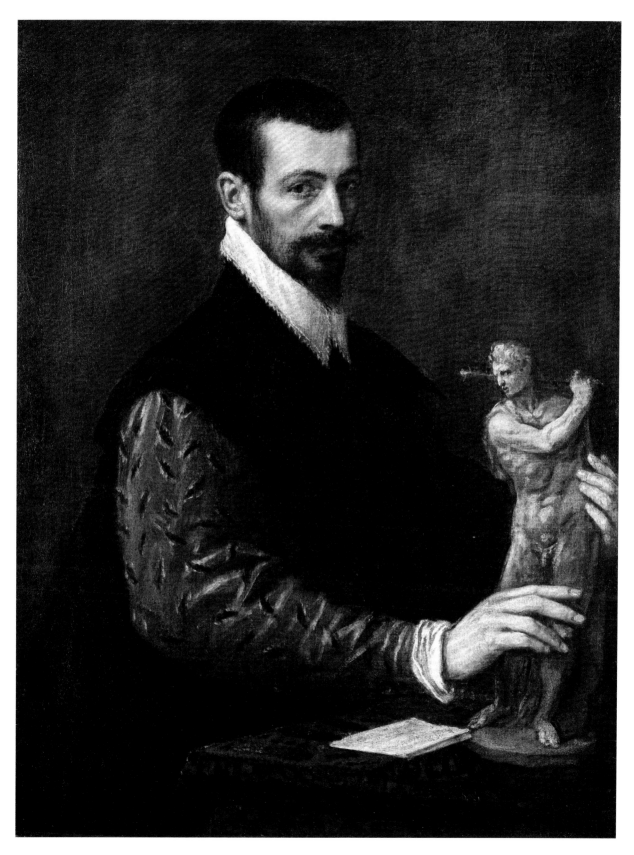

49

9

Cristofano Allori
(1577–1621)

Judith with the Head of Holofernes

Signed and dated 1613
Oil on canvas, 120.4 × 100.3 cm
RCIN 404989

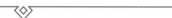

Acquired by Charles I, probably from the Gonzaga collection, Mantua

From the early Renaissance, artists included self-portraits in historical scenes, and the tradition continued long into the seventeenth century, as seen in this portrayal of the Old Testament story of Judith and Holofernes. Judith of Bethulia beheaded Holofernes, an Assyrian general, with his own sword to save her city. Allori's turbulent relationship with Maria de Giovanni Mazzafirri (known as 'La Mazzafirra'), and his misery at their unhappy affair, informed this depiction of La Mazzafirra as Judith and her mother as the maid; Holofernes is the aggrieved artist's self-portrait. The placement of the severed head at the edge of the picture, close to the viewer, heightens the drama and shock of the picture without explicitly illustrating any bloodshed.

In this painting, the richness of materials is emphasised by comparison. Allori pitches the shimmering draperies of Judith's luxurious yellow dress and cloak with crimson lining against the matted tufts of Holofernes' hair. The light shining on the golden damask highlights the pattern's rhythmic quality, against the disorderly mop of the severed head. Allori consistently compares the most ugly with the most beautiful, drawing attention to both extremes as he moves unflinchingly from Holofernes' heavy features and distraught expression to Judith's faultless complexion and magisterial expression.

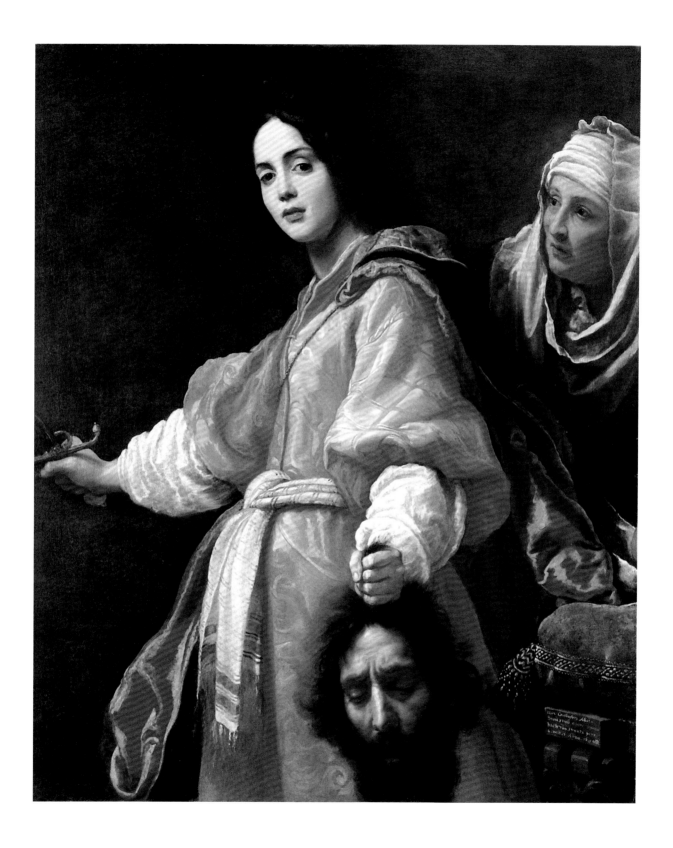

10

Domenico Fetti
(1588–1623)

Vincenzo Avogadro

1620
Oil on canvas, 115.4 × 90.3 cm
RCIN 405327

Acquired by George III in 1762 as part of the collection of Joseph Smith, British Consul in Venice

An inscription along the arm of the chair identifies this sitter as Vincenzo Avogadro, a Mantuan rector, and gives his age as 35. However, the same inscription dates the picture to 1610 ('MDCX'), which is not consistent with 1630, Avogadro's date of death. Presumably the portrait was painted in 1620, and a second 'X' was either omitted or overpainted at the end of the inscription. Avogadro was the rector of the church of Santi Gervasio e Protasio in Mantua, where Domenico Fetti painted an altarpiece in 1619–20. The sitter is probably standing in the sacristy of the church, in front of a crucifix and a richly embroidered altar cloth which, along with his now-faded blue costume, indicates his high-standing.

Avogadro's formidable stare, sharp cheekbones, neatly combed hair and starched white collar lend the portrait a captivating intensity, a pictorial metaphor for his piety. His knuckles seem to turn pink from the tight grip in which he holds his book, presumably of prayers, and a vein bulges in his forehead, betraying the potential anguish that such powerful faith might invoke.

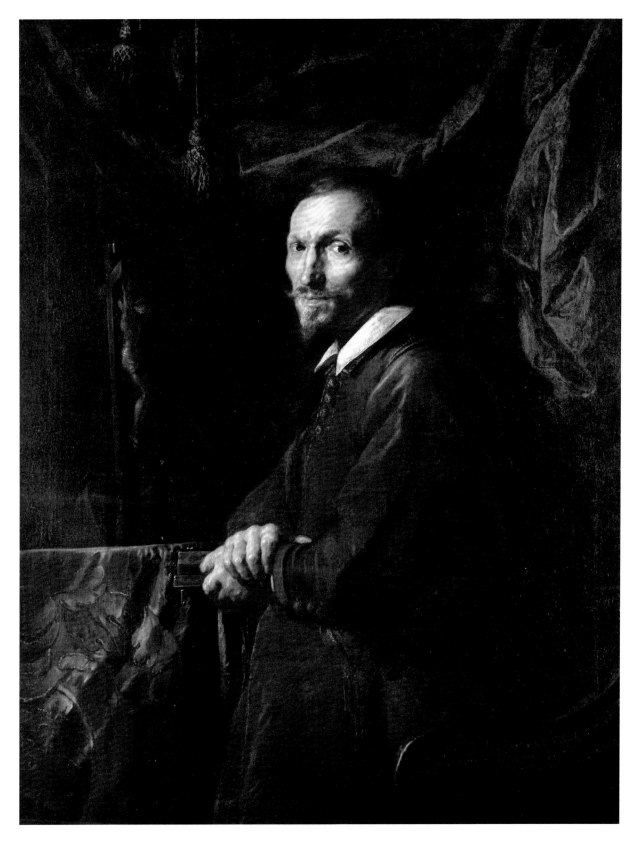

11

Guido Reni
(1575–1642)

Cleopatra with
the Asp

c.1628
Oil on canvas, 114.2 × 95.0 cm
RCIN 405338

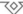

Acquired by Frederick, Prince of Wales, by 1749

Consistent with his many depictions of tormented women, this dramatic painting by Reni shows the Egyptian queen Cleopatra in the final seconds of her life, just before she commits suicide. The basket of fruit used to smuggle in the asp is to her side, and the snake rears back, ready to bite. We watch the colour drain from her body, illuminated against the dark background. Her extremities are still tinged with pink, but her torso has already begun to resemble the opalescent colour and smooth texture of marble. The folds in the fabric also take on the appearance of a smoothly carved sculpture, symbolising her tragic transition from life to death.

The genesis of the painting is somewhat unusual. On behalf of a Venetian merchant called Boselli, the artist Palma Giovane is said to have asked Reni for a picture of Cleopatra so that it could be judged against a half-length of his own and those of fellow painters Guercino and Niccolò Renieri. Although Reni did not win the competition, his picture was clearly held in high esteem, as on the death of Boselli it was acquired by Renieri.

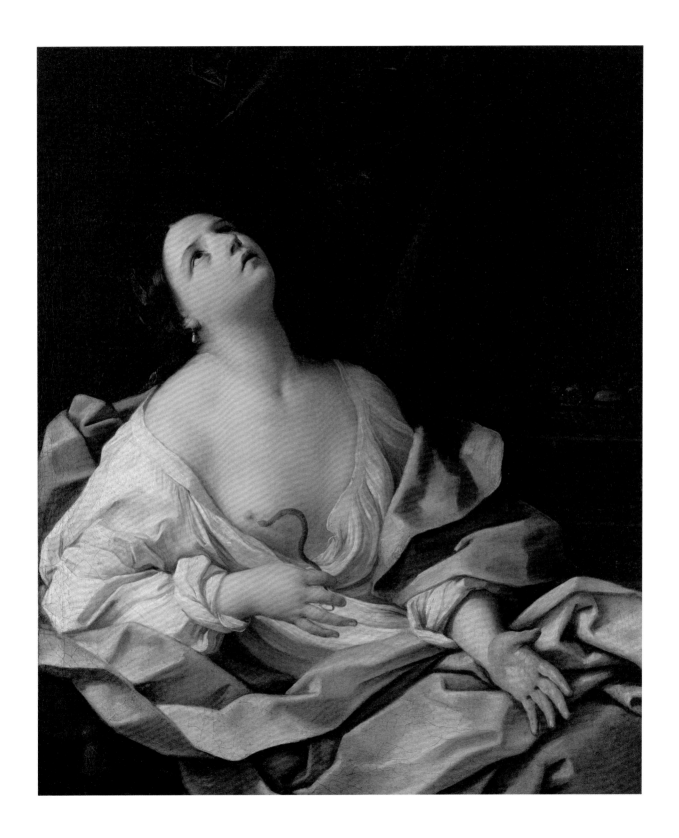

12

Guercino
(1591–1666)

The Libyan Sibyl

1651
Oil on canvas, 116.3 × 96.5 cm
RCIN 405340

First recorded at Buckingham House c.1790

The Libyan Sibyl's most commonly shown attribute is a lighted torch, but Guercino instead identifies her through the inscription on the book on which she rests her elbow. The Sibyl was one of 12 prophetesses from the classical world who foretold the coming of Christ. Sibyls were a popular subject of seventeenth-century Italian painting, probably inspired by their prominence in Michelangelo's Sistine Chapel ceiling. Guercino executed many versions throughout his career. This Libyan Sibyl is one of a pair with the Samian Sibyl, commissioned by Ippolito Cattani, for which he paid 150 *scudi*. It was probably acquired for George III by his Librarian, Richard Dalton, and was hung in the Queen's Warm Room at Buckingham House.

The Sibyl's sensitivity is conveyed through her rounded, idealised features, which harmonise with the supple rhythmic fall of the draperies. The warm tonality of the brown and orange cloth is set against the Sibyl's blue dress. The close proximity of these complementary colours enhances the vibrancy and balance of the picture.

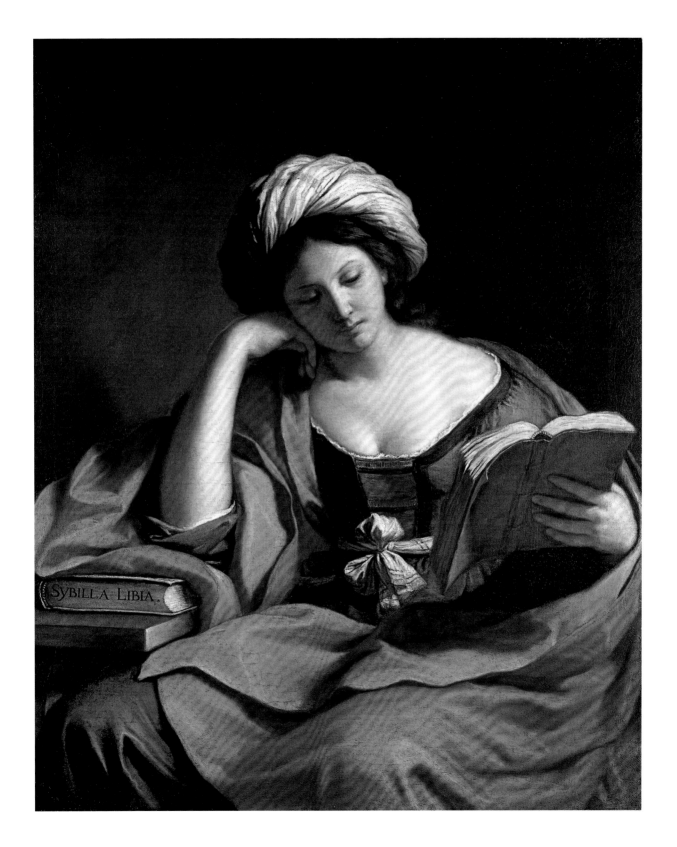

13, 14

Guido Cagnacci
(1601–1663)

Jacob Peeling the Rods

*c.*1650
Oil on canvas, 148.8 × 186.5 cm
RCIN 406088

Filippo Lauri
(1623–1694)

Jacob Fleeing from Laban

1686
Oil on canvas, 93.3 × 142.0 cm
RCIN 406356

◇

Both probably acquired by Frederick, Prince of Wales, before 1750

Two pictures by Cagnacci and Lauri portray Biblical scenes from the life of Jacob (Genesis 30–32). Laban's two daughters, Rachel and Leah, both married Jacob and their dowry included half of their father's flock. Laban promised all his speckled sheep to Jacob, who put peeled rods in their drinking trough (as seen in the left of cat. 13). When the strongest sheep mated, he ensured that they did so in front of the rods, which produced a great number of speckled lambs. Jacob's riches increased because of this genetic engineering, and he was soon forced secretly to flee from his father-in-law (as shown in cat. 14).

Perhaps the most striking difference in the design of these two pictures is their 'zoom'. Cagnacci paints Jacob, Leah and Rachel close to the picture plane, and the figures loom down into the viewer's space. The picture is composed of three pieces of canvas, with additions to the top and right made either during painting or very shortly afterwards to enlarge the composition. Even with the additions, the composition remains tight, intensified by the heavy shadows cast over the figures' faces. Lauri's scene, by contrast, is set in a landscape that distances the viewer from the action. Jacob sits on a horse at the centre of the composition, followed by his wives, children and livestock, presumably on their way to Mount Gilead. The space accentuates the extent of Jacob's accumulated riches, as the long train of horses and people that follows him blurs into the background.

Both pictures were acquired by Frederick, Prince of Wales, and later hung at Buckingham House, the Lauri in George III's Bedchamber and the Cagnacci in Queen Charlotte's Warm Room. Lauri's picture is surrounded by an outstanding example of an eighteenth-century Italian Salvator Rosa frame, with finely carved foliage that sings against the dark background beneath.

59

15

Claude Lorrain
(1604/5–1682)

Harbour Scene at Sunset

Dated 1643
Oil on canvas, 74.3 × 99.4 cm
RCIN 401382

Probably acquired by Frederick, Prince of Wales. First recorded at Buckingham House c.1790

When Claude became famous in the 1630s, he started to keep a record of every one of his paintings in a series of drawings called the *Liber Veritatis* ('Book of Truth'). This was intended to avoid forgeries, but another advantage of the practice was that Claude's clients could order repetitions of previous compositions. This painting matches *Liber Veritatis* number 19, which can be dated to 1637 from its position in the sequence; the fact that cat. 15 is dated 1643 would suggest that this is a second version of that composition, though the first no longer survives. Claude never treated these repeat compositions with any less care than his other paintings, as can be seen in this beautifully finished and well-preserved landscape.

Many artists have imitated Claude's Romantic port scenes; most look bland and formulaic by comparison with the original. They copy the subtle gradations of Claude's sky, shifting from yellow to blue, but they miss his observation of the intense darkness of a slightly choppy sea at dusk. They capture the soft veil of misty light in the distance, but miss the sharpness of the foreground architecture.

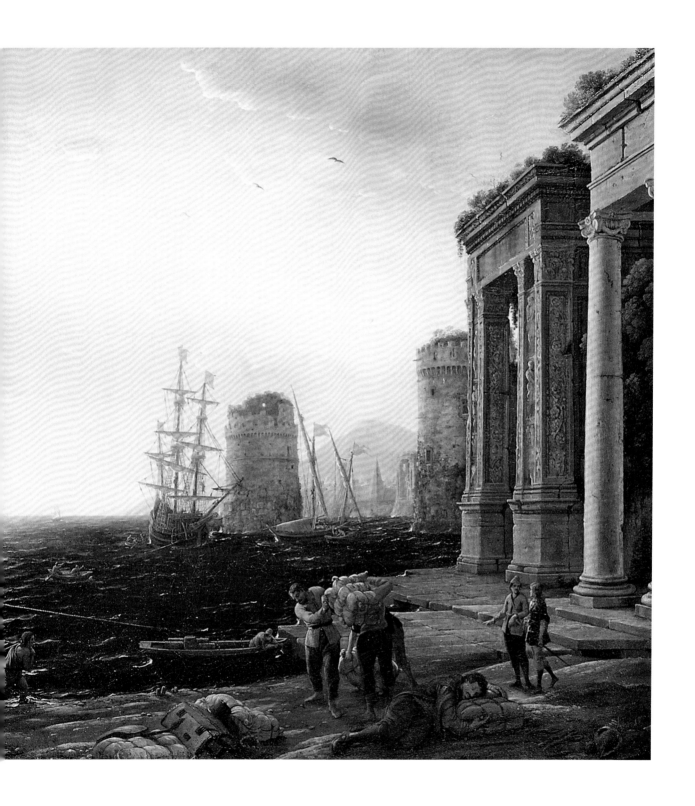

61

16

Claude Lorrain
(1604/5–1682)

A View of the Campagna from Tivoli

1645
Oil on canvas, 98.2 × 131.2 cm
RCIN 404688

Acquired by Frederick, Prince of Wales, in 1742

This composition is number 89 in Claude's *Liber Veritatis*, one of a pair painted in 1645 for Michel Passart, a government financier (*maître des comptes*) in Paris and later a patron of Nicolas Poussin. The companion picture (at the Musée de Grenoble), presumably designed to hang on the left, shows the Temple of Vesta at Tivoli seen from below in clear morning light. The relationship between the two is typical of Claude, exploiting contrasts and implying a narrative sequence: climbing the hillside at Tivoli in the morning; later watching the sun set from its summit.

The viewpoint here is unusual, looking down from a hilltop, with a high horizon. Claude's landscape depicts the final moments of a sunset, as opposed to diffused early evening light. The light passes through the spectrum from orange through intense red to blue, forming a dome around the sun. The land is drained of almost all light and colour and is veiled in a grey mist. The tiny bump on the horizon is the dome of St Peter's Basilica in Rome.

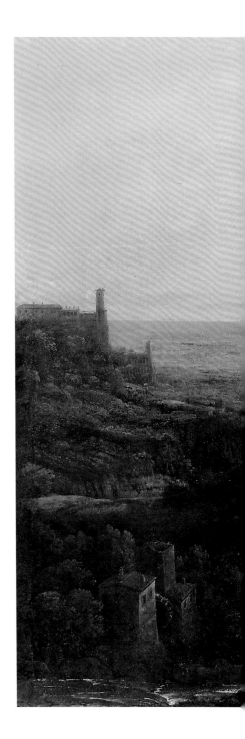

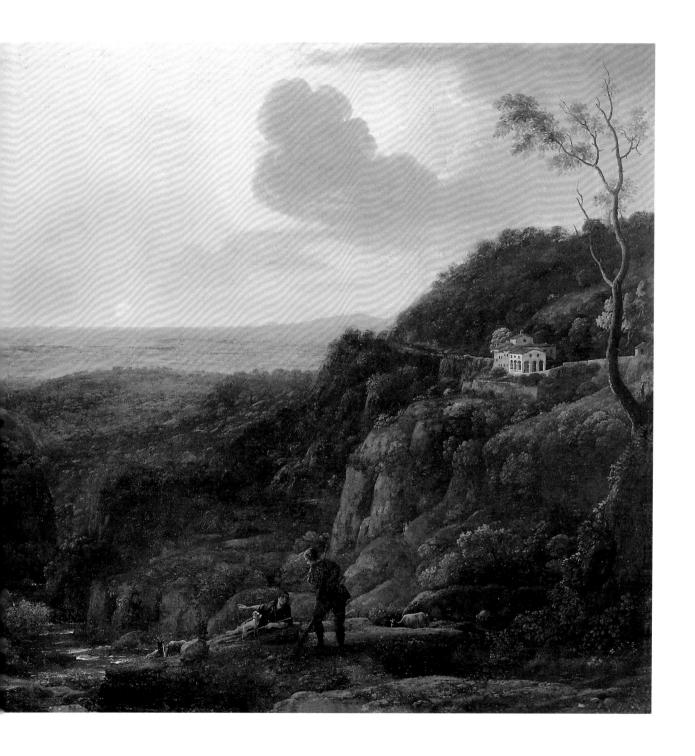

17

Claude Lorrain
(1604/5–1682)

Coast Scene with the Rape of Europa

Signed and dated 1667
Oil on canvas, 102.0 × 134.9 cm
RCIN 405357

◇

Acquired by George IV in 1829

Like cat. 15, this Claude landscape repeats an earlier design.
The *Liber Veritatis* drawing for it, number 136, is inscribed
with the name of both clients: the first, Pope Alexander VII,
received his version in 1655 (now in the Pushkin Museum,
Moscow); the second, Philippe de Graveron, acquired this
picture in 1667. In his late work Claude creates an atmos-
pheric unity with a very limited chromatic range – in this
case dominated by a silvery blue. His touch with the brush
has a softness, as if he seeks to depict the air surrounding the
forms, as well as the forms themselves.

The story comes from Ovid's *Metamorphoses* and tells how
Europa, a princess of Tyre, was gathering flowers with her
handmaidens by the sea shore. Enamoured with her, Zeus
joined the nearby herds, disguising himself as a perfect white
bull. Europa adorned the playful bull with flowers and rode
on his back, only to be taken out into the waves and across
the sea to Crete.

18

Gaspard Dughet
(1615–1675)

Seascape with Jonah and the Whale

c.1654
Oil on canvas, 97.8 × 136.1 cm
RCIN 405355

Acquired by Frederick, Prince of Wales, in 1748

Gaspard Dughet was born to a French family living in Rome. He was inspired to take up painting when his father took a lodger, Nicolas Poussin, who later married Gaspard's sister. Until the twentieth century he was generally known as Gaspar Poussin, the name he adopted from his brother-in-law. This work was believed by Frederick, Prince of Wales, to be a collaboration between the two, the landscape by Gaspard and the figures by Nicolas.

The Book of Jonah tells how that prophet attempted to flee from God's commands by sea and was prevented by a storm, which could only be calmed by throwing him from the ship. Once sacrificially cast overboard he was swallowed by a giant fish, which disgorged him three days later at Nineveh (where he should have gone in the first place). This was a favourite subject for artists of the period; for its spiritual meaning, as a reminder of Christ's sacrificial death and rebirth, and for the dramatic potential of the storm and monstrous fish.

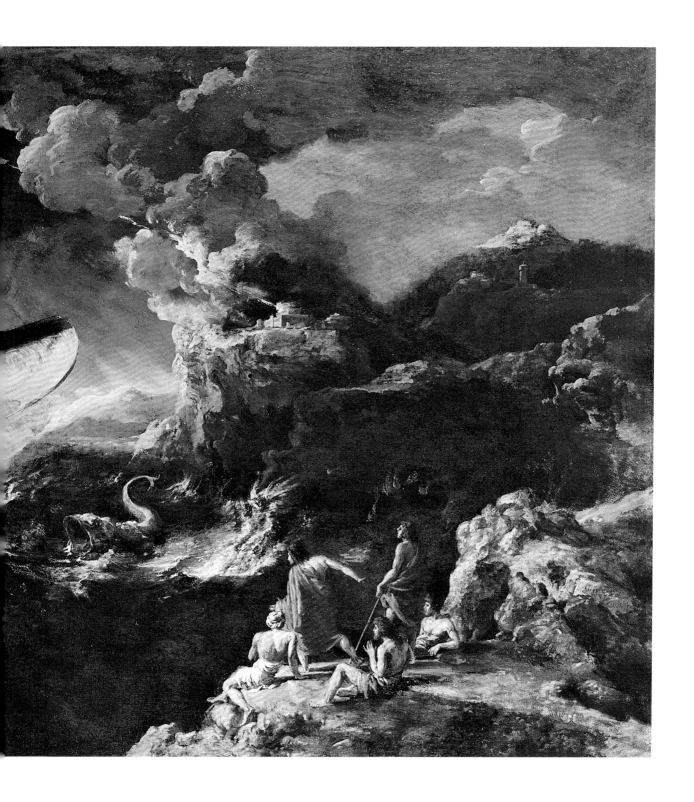

19–22

Canaletto
(1697–1768)

The Piazza Looking North-West with the Narthex of San Marco

*c.*1723–4
Oil on canvas, 172.3 × 133.7 cm
RCIN 401037

The Piazzetta Looking North towards the Torre dell'Orologio

*c.*1723–4
Oil on canvas, 172.8 × 135.2 cm
RCIN 405074

The Piazzetta Looking towards Santa Maria della Salute

*c.*1723–4
Oil on canvas, 172.3 × 136.5 cm
RCIN 405073

The Piazzetta Looking towards San Giorgio Maggiore

*c.*1723–4
Oil on canvas, 173.0 × 134.3 cm
RCIN 401036

19

21

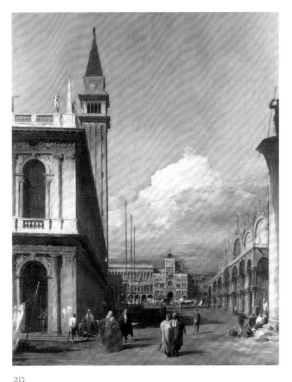

20

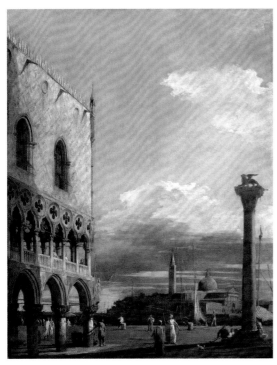

22

Acquired by George III in 1762 as part of the collection of Joseph Smith, British Consul in Venice

These four early paintings by Canaletto belong to a set of six views of the Piazza San Marco and Piazzetta in Venice. Their similar sizes, corresponding compositions and fluid handling of paint suggest that the pictures were designed to hang together in a specific interior. They were the first in a long series of commissions that Canaletto received from Joseph Smith, British Consul in Venice. After they were acquired by George III, the pictures were hung in 'Carlo Maratta' frames in the Entrance Hall of Buckingham House.

Canaletto manipulated the details of Venetian topography in his views of the city, exaggerating certain features and reducing others to frame the spectacle of everyday life. The placement and gestures of the figure groups were no doubt informed by the artist's early experience as a theatre set painter.

Canaletto's masterful use of colour draws attention to certain figures. In cats 19 and 20 a Procurator, the highest ranking dignitary in the city after the Doge, is identifiable in long scarlet robes. Sunlight highlights the intense red colour, probably vermilion. In cat. 19 the Procurator approaches other government officials (*comandadori*), whose chalky-blue robes and red caps are similarly illuminated. Bold brushstrokes of blue, red and yellow in the canopies behind complement the colours of the costumes.

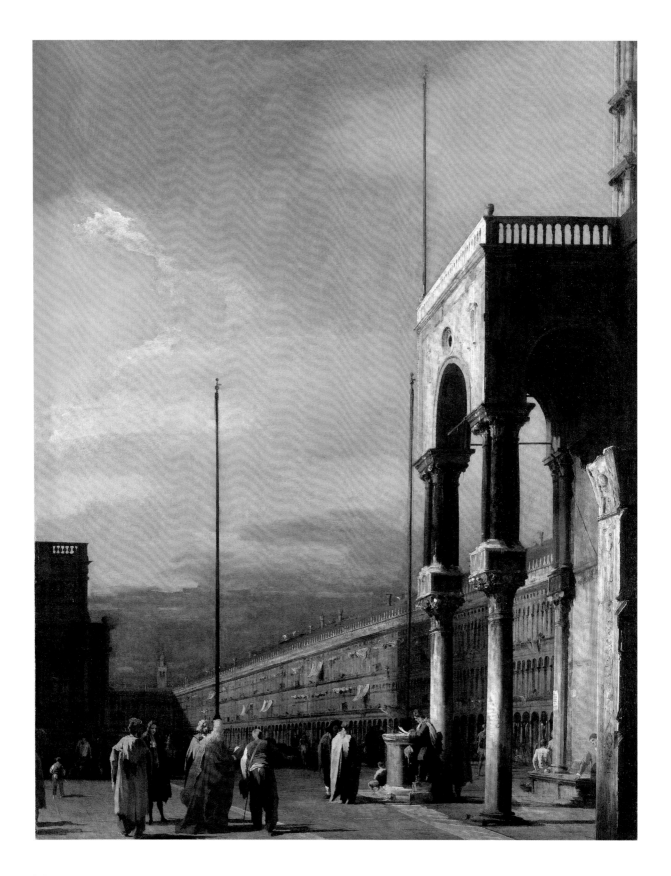

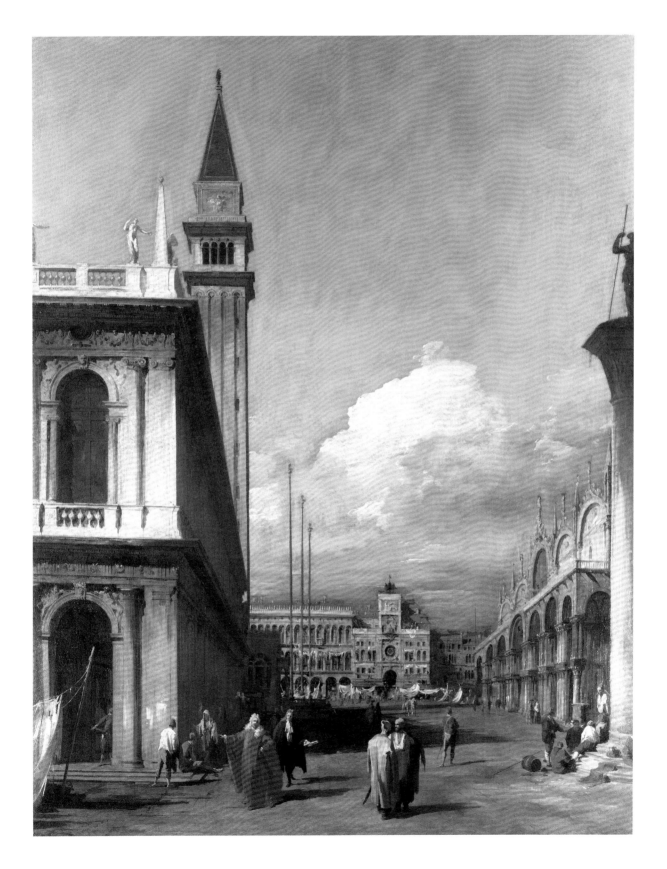

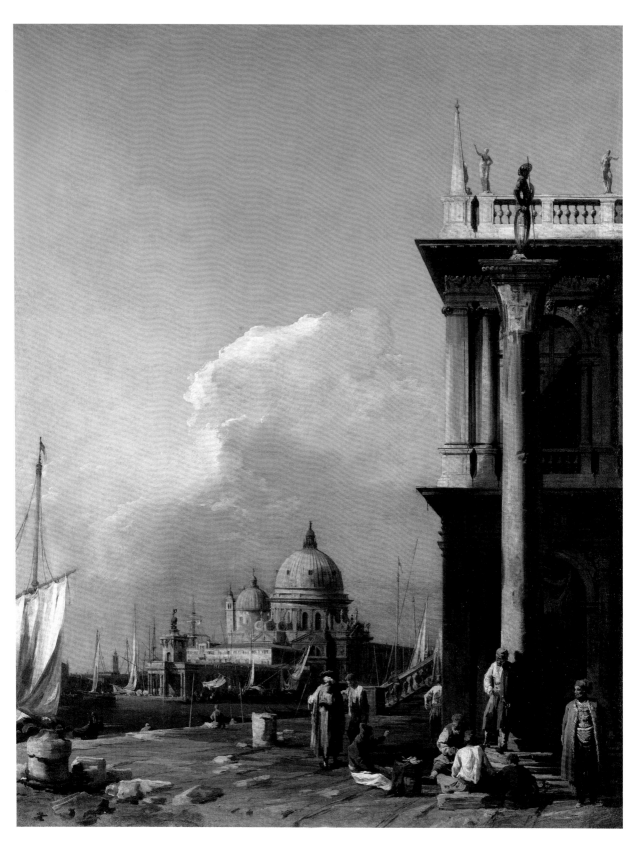

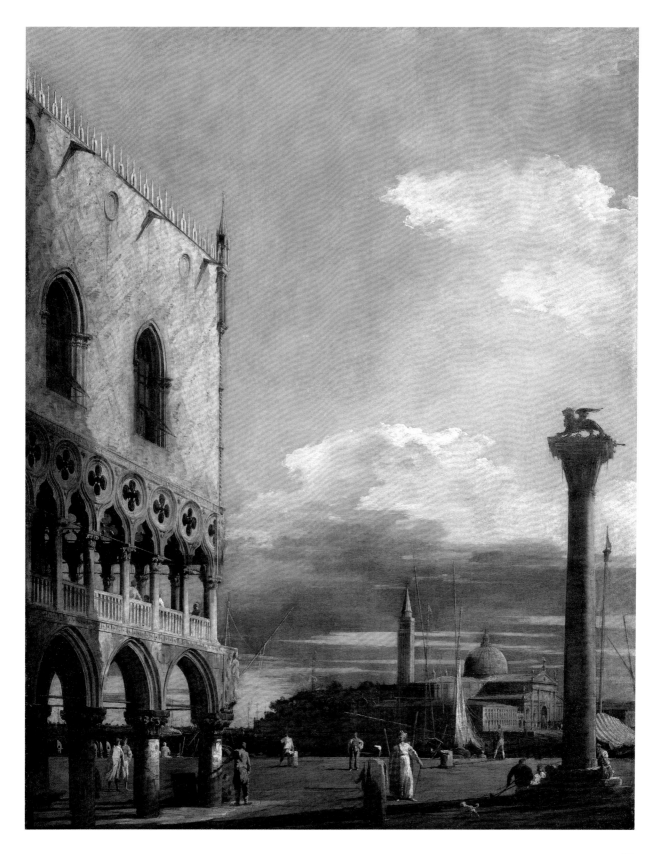

23

Canaletto
(1697–1768)

The Bacino di San Marco on Ascension Day

*c.*1733–4
Oil on canvas, 76.8 × 125.4 cm
RCIN 404417

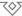

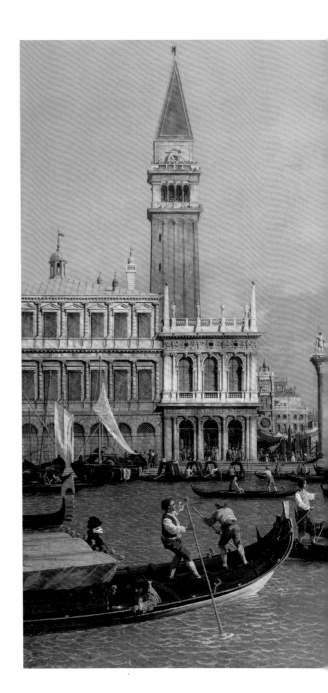

Acquired by George III in 1762 as part of the collection of Joseph Smith, British Consul in Venice

Canaletto transports us to one of the liveliest days in the Venetian calendar, the Marriage with the Sea on Ascension Day. The *Bucintoro*, the red and gold boat that dominates the right-hand side of the picture, was at the heart of the ceremony commemorating the city's alliance with the Adriatic Sea. It carried the Doge out across the lagoon to drop a ring into the sea, with the words, 'We espouse thee, O sea, as a sign of true and perpetual dominion'. Canaletto portrays the moment that the boat returns to the Bacino di San Marco. From the presence of the ducal umbrella and standards on the front deck, it is clear that the Doge must still be on board.

Canaletto brings the bustling city to life using a variety of techniques. Thickly textured paint conveys the three-dimensionality of cloth, emphasising the sag of the awnings and the creases in the rowers' costumes as they heave their oars. Lines of thinner paint are 'drawn' on to define the curves of the boat bows, and to describe specific architectural details.

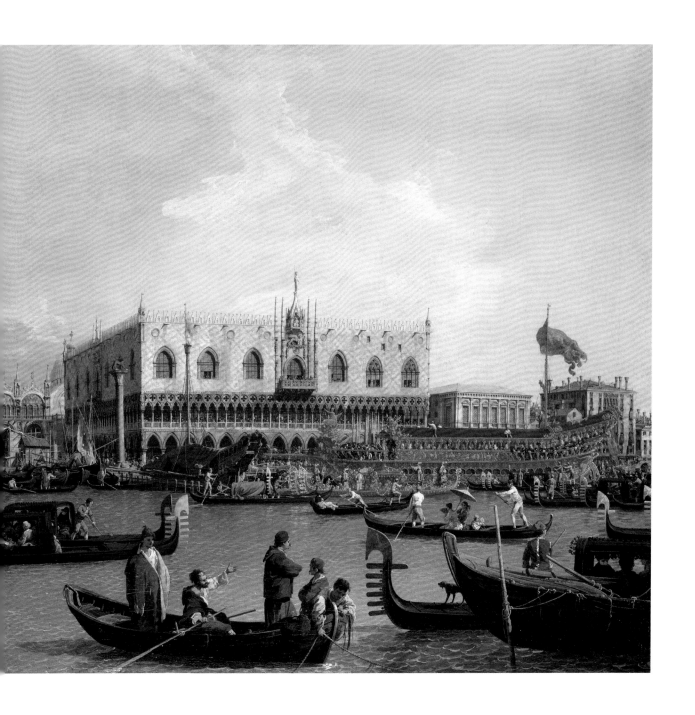

24

Sir Peter Paul Rubens
(1577–1640)

The Assumption of the Virgin

c.1611–12
Oil on panel, 102.1 × 66.3 cm
RCIN 405335

Acquired by George IV in 1816, when Prince Regent

When Rubens visited Italy between 1600 and 1607 there was an ongoing debate in art between the advocates of drawing and of colour. Rubens devoted his career to reconciling the two. This is a preparatory work but it is a full-colour oil sketch, not a drawing. The composition, outlines and expressive patterns of the forms are achieved with a brush rather than a pen. Rubens gave oil sketches like this to his pupils for them to prepare (and often largely execute) finished paintings of four to five times the size. This was one of Rubens' earliest depictions of the Assumption, and numerous *pentimenti* show him experimenting with the composition.

The use of this oil sketch was more complicated than normal, as it does not correspond exactly to any of his finished altarpieces. It would seem that Rubens offered his client two options: this composition and the one represented by an oil sketch now in the Hermitage, St Petersburg. They chose to mix and match, with the result that the finished work (now in the Kunsthistorisches Museum, Vienna) copies the upper part of this composition, but takes the Apostles below entirely from the Hermitage sketch.

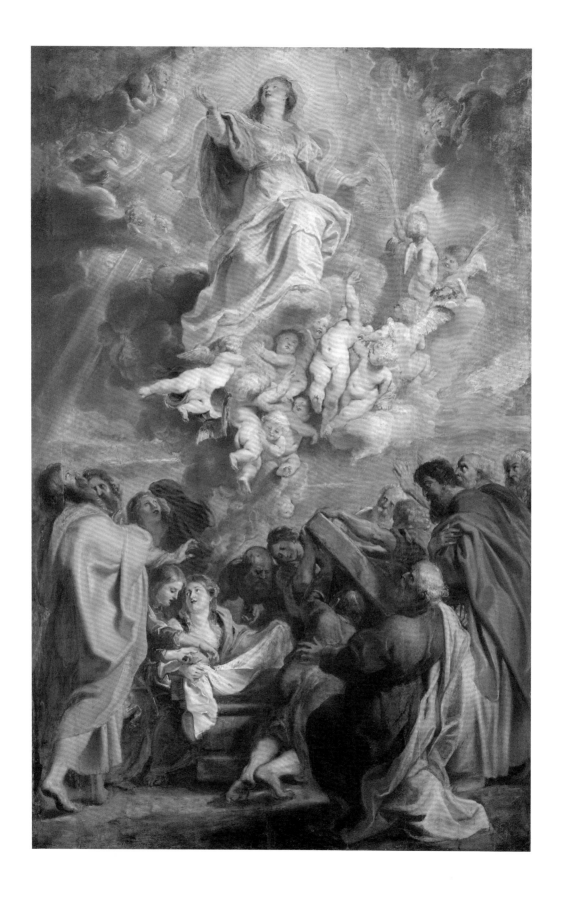

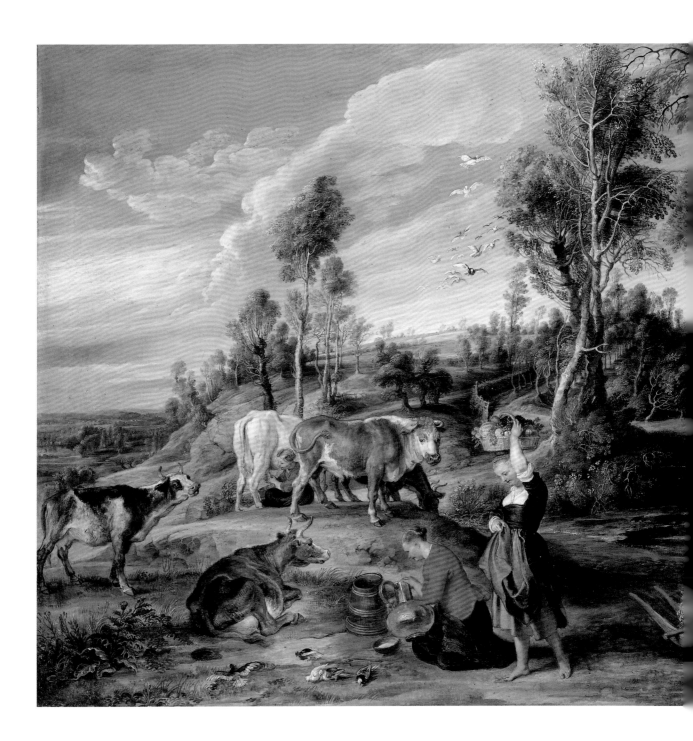

25

Sir Peter Paul Rubens
(1577–1640)

Milkmaids with Cattle in a Landscape ('The Farm at Laken')

c.1617–18
Oil on panel, 85.9 × 125.9 cm
RCIN 405333

Acquired by George IV in 1821

Rubens was nearly 40 by the time he took up landscape painting and then apparently only as a pastime. This work seems to have 'stayed in the family': it was first mentioned in the collection of the Lundens of Antwerp, descendants of Rubens' second wife, Helena Fourment. As often in his landscapes, Rubens added pieces of panel to allow his composition to grow as he worked on it – a strip of 7 cm on the left; one of nearly 15 cm to the right; and another, about 13 cm high, all across the top. In total, the panel is composed of six sections.

This work reads as an idealised pastoral group, with beautifully drawn cattle arranged like a family, a wheelbarrow (heaving with vegetables) and country maids, one bearing produce on her head, like an allegory of Plenty. Around this figure composition Rubens disposes – with little concern for perspective – an array of vivid landscape incidents: a dark hollow, an avenue of trees and a glimpse of a village with a church. There appear to be two distinct horizon lines, one to the left and another, much higher, in the centre.

26, 27

Sir Peter Paul Rubens
(1577–1640) and Workshop

Summer: Peasants
Going to Market

c.1618
Oil on canvas, 143.4 × 222.9 cm
RCIN 401416

Winter: The
Interior of a Barn

c.1618
Oil on canvas, 121.4 × 223.1 cm
RCIN 401417

Acquired as a pair by Frederick, Prince of Wales, in 1747

These landscapes were treated as a pair by Frederick, Prince of Wales, contrasting night with dawn, winter with summer. This does not mean that Rubens created them as a pair. They both have additions, *Winter* gaining 60 cm on its left side (everything to the left of and including the circular basket); *Summer* gaining some 30 cm either side and 20 cm across the bottom. These appendages mean that the widths match (though not the heights), but they may have occurred for other reasons entirely.

In *Summer*, Rubens uses many of the conventions of Flemish landscape painting invented by Pieter Bruegel the Elder: a brown foreground, green middle ground and blue distance; and a bird's-eye perspective that seems to be able to float over features, however high or far off. He wishes to show every type of landscape and every means by which it is adapted for human use. We see a hamlet, an aristocratic estate, a small country town and a distant city. We see forestry, pigs, cattle and sheep as well as the produce of arable farming. Everything seems to pour, like a river of plenty, towards the market.

Winter appears to have been inspired by Rubens' nocturnal treatments of the Adoration of the Shepherds, though here he has expanded the traditional barn setting into something panoramic, with three distinct figure groups and two landscape vistas seen through the uprights.

28

Sir Peter Paul Rubens
(1577–1640)

Self-Portrait

Signed and dated 1623
Oil on panel, 85.7 × 62.2 cm
RCIN 400156

Presented to Charles I, when Prince of Wales

This portrait was commissioned by Henry Danvers, later Earl of Danby, in order that he might present it to the Prince of Wales, later Charles I. Rubens knew the ultimate destination of the work and clearly wished to impress the young Prince (of a nation we might call an 'emerging market'): he presents himself as an almost casually brilliant painter and as a handsome, courtly man.

Italian artists create the effect of three dimensions (often called 'modelling') by shading, giving forms a light and a dark side. Rubens models with colour. He exaggerates the contrasts of colour which may be observed in flesh tones, especially in different lights. He exploits the fact that warm colours (oranges and browns) seem to advance while cool colours (blues and greys) seem to recede. This is not systematic like perspective; it is simply that shifting colours create the effect of shifting planes, just as curving lines (another Rubens speciality) suggest round rather than flat things.

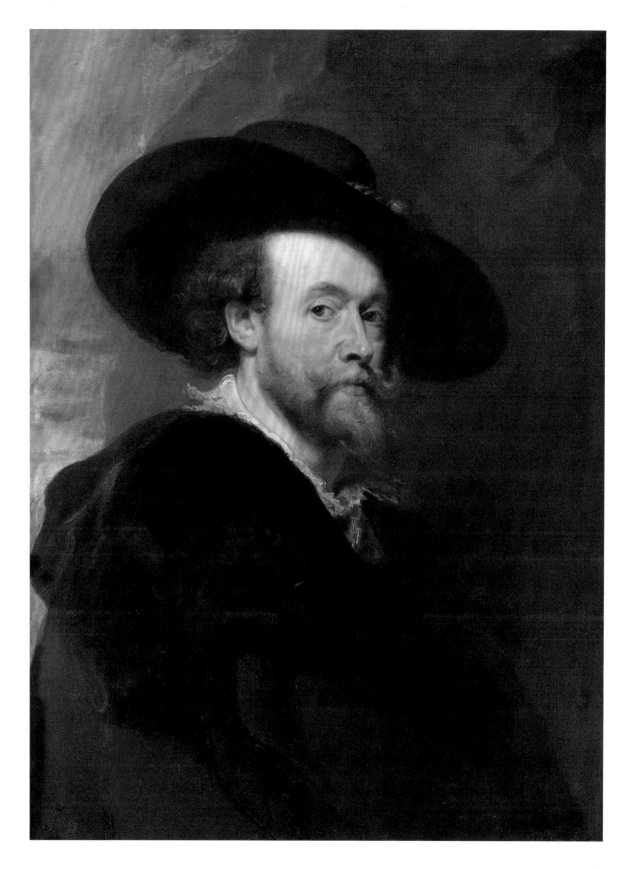

29

Sir Peter Paul Rubens
(1577–1640)

Portrait of a Woman

*c.*1630
Oil on panel, 86.8 × 59.3 cm
RCIN 400118

Acquired by George IV in 1818, when Prince Regent

This beautifully informal portrait was first recorded in the collection of Rubens' in-laws, the Lundens. It was acquired by the future George IV as a depiction of the painter's second wife, Helena Fourment. It is more likely that the sitter is one of Helena's sisters or another member of the family. The panel has three oil sketches of historical subjects on the reverse, which technical analysis shows were completed after the portrait. The panel must therefore have been abandoned in the studio until it was reused, reinforcing the assumption that this portrait was a private family matter.

Rubens paints with a kind of *vibrato*. He creates forms with a curving, wobbling line, suggestive of movement and extrovert expression. The gold and white paned sleeves and crossed arms here suggest motion and express modesty in the presence of the viewer, as does the slight smile. The light creates a pool around her breast, while the contours of the figure sink into a mysterious dark background. These things suggest more 'inwardness' than we sometimes associate with Rubens.

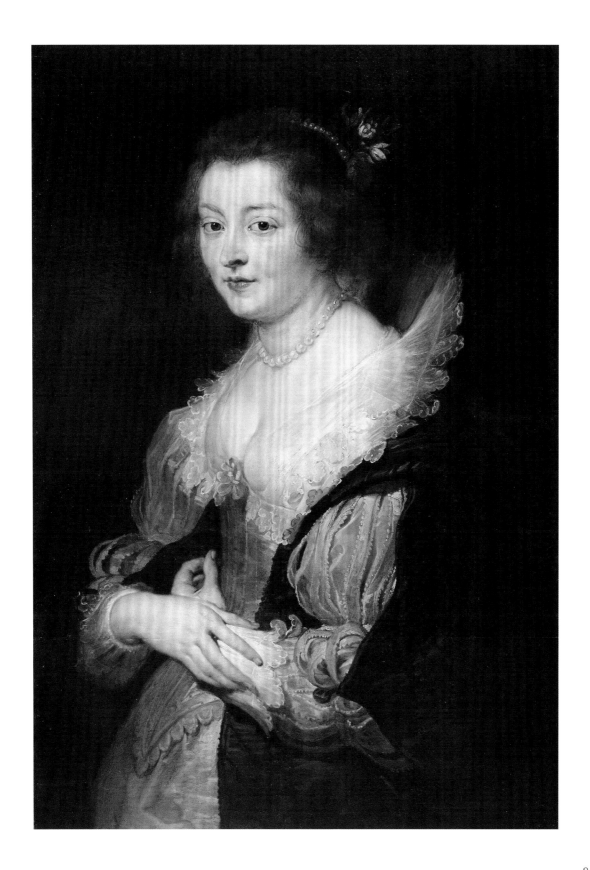

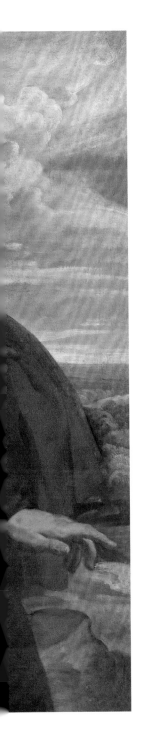

30

Sir Anthony van Dyck
(1599–1641)

Christ Healing the Paralytic

1618–19
Oil on canvas, 120.2 × 148.8 cm
RCIN 405325

Acquired by George IV in 1811, when Prince Regent

In the Gospels Christ heals the affliction of the paralytic man, so that, as here, he may take up his bed and walk. He does so only after Christ has forgiven his sins. To the seventeenth-century mind, physical and spiritual affliction appeared the same and are expressed here in the gnarled body of the paralytic in comparison with the regular features of the haughty disciple to Christ's left.

Van Dyck uses a compositional device invented by Caravaggio, whereby the canvas area is filled with a small number of life-size, standing figures, shown in three-quarter length. The idea is to maximise the presence and impact of the actors in the scene, through their scale and bulk. The arrangement can also create the illusion that the viewer is a participant in the drama.

31

Sir Anthony van Dyck
(1599–1641)

The Mystic Marriage
of St Catherine

*c.*1630
Oil on canvas, 126.2 × 119.5 cm
RCIN 405332

Acquired by George IV in 1821

The Christ Child appeared to St Catherine of Alexandria in a vision, offering her a ring as a symbol of their everlasting spiritual betrothal. St Catherine was martyred for refusing to renounce her heavenly spouse; here she holds a martyr's palm and leans on the wheel upon which she was to have been executed (in the event it shattered and she was beheaded).

The expressive power of the image is embodied in the many contrasts between the three figures: between the impassive marble-like profile of the Virgin, the hair-down dishevelment of the suffering saint and the tender concern of the pudgy baby. The three also seem to be colour-coded: the Virgin appears in red and blue, the Christ Child is almost purely white, while the figure of the saint is made up entirely of black and gold, colours symbolic of suffering and glory.

Sir Anthony van Dyck
(1599–1641)

Thomas Killigrew and
(?) William, Lord Crofts

1638
Oil on canvas, 132.9 × 144.1 cm
RCIN 407426

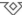

Acquired by Frederick, Prince of Wales, in 1747

Thomas Killigrew (1612–83) was page to Charles I, companion to Charles II during his exile and a prominent courtier after his return. He was also a dramatist and stage manager, who played a central role in the revival of the theatre at the Restoration. His work is now best known through Aphra Behn's *The Rover* of 1677, an adaptation of his *Thomaso, or The Wanderer* of 1664.

Killigrew's first wife, Cecilia Crofts, died in the same year that this portrait was painted. His bereavement is alluded to by the broken column behind him and the tomb design he holds in his right hand. His mood is expressed through a careless lassitude of posture, which contemporaries would have recognised as a symptom of melancholy. His companion has been identified as his nephew by marriage, William Crofts (1611–77), but may simply be his secretary. He points to a sheet of paper as if asking the poet to write an appropriate epitaph. It remains blank, perhaps to suggest that the author's grief is too profound to be put into words.

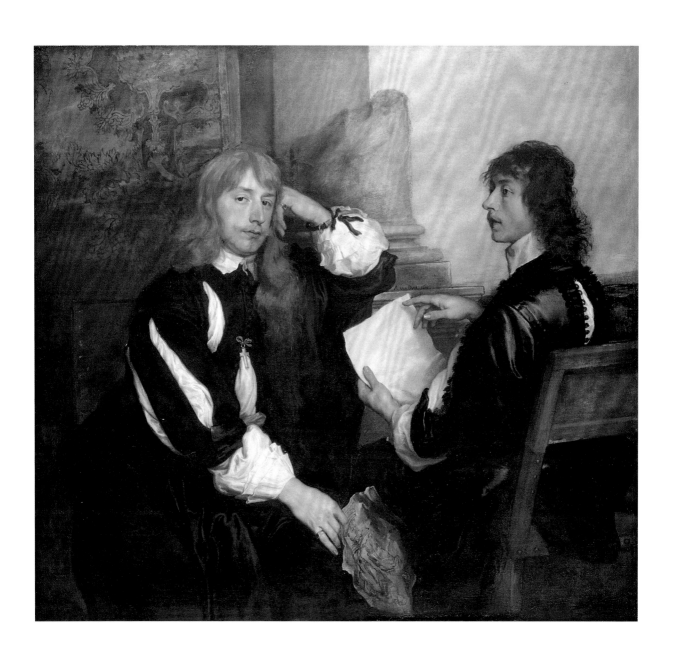

33

Hendrick ter Brugghen
(1588–1629)

A Laughing Bravo with a Bass Viol and a Glass

Signed and dated 1625
Oil on canvas, 104.8 × 85.1 cm
RCIN 405531

Acquired by Charles I

In his inventory of Charles I's collection undertaken around 1639, the King's Surveyor, Abraham van der Doort, described this figure as 'a drunken swaggering laffing fellowe'; he would have been recognised by an English audience as a 'braggart', a troublesome ne'er-do-well like Shakespeare's Pistol. During his sojourn in Rome from 1607 until 1614, ter Brugghen was inspired by the works of Caravaggio and his followers, which included many menacing, over-dressed 'bravos' like this. The bravo's costume features elements from contemporary fashion, such as the voluminous, paned sleeves, combined with items inspired by historical dress, like his big hat with large feathers. This work is typical of the three-quarter-length character studies produced by ter Brugghen on his return to Utrecht.

The style of painting is appropriate to the type of man: executed broadly and freely in cheap earth colours, with a staccato effect of light and shade and an apparently haphazard composition. The scene is unprepossessing, unedifying and impermanent; we admire only the confidence and lively brilliance with which it is portrayed.

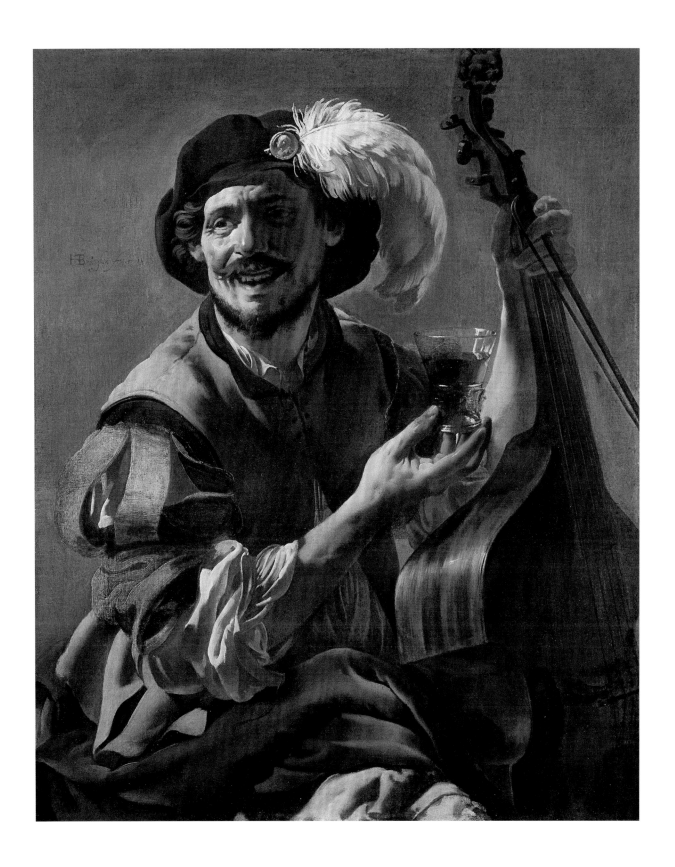

93

34

Frans Hals
(c.1580–1666)

Portrait of a Man

Dated 1630
Oil on canvas, 116.7 × 90.3 cm
RCIN 405349

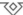

First recorded at Buckingham House c.1790

This casually posed, brilliantly painted figure against an apparently untouched background may be compared to ter Brugghen's *Bravo* (cat. 33). It shares that quality of carelessness – that ability to 'conceal all art and make whatever is done or said appear to be without effort and almost without any thought about it' (to quote from Baldassare Castiglione's *The Book of the Courtier*, 1528).

The unknown sitter here is a very different type of person – prosperous and respectable, wearing fashionable silk satin, an intricate linen ruff and holding kidskin gloves. Extremes of black and white in costume are always indicators of luxury. They also give the figure a quality that might in modern slang be called 'sharp' – with crisp details and an expressive, 'snappy' outline. In the eighteenth century this fashionable look was captured by cutting silhouettes – creating a recognisable image of a person in black paper. In his 1774 *Discourse*, Sir Joshua Reynolds perceived something similar in Hals' 'composition of the face', with 'features well put together, as the painters express it'. Reynolds concluded that if Hals had had 'a patience in finishing what he had so correctly planned' he would be the equal of van Dyck.

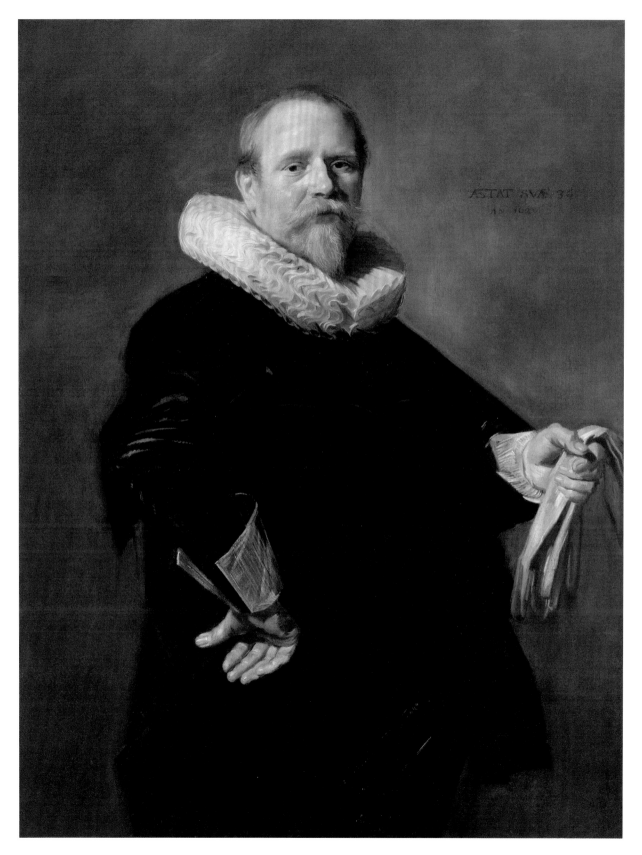

ÆTAT SVÆ 34
AN 1627

95

35

Rembrandt van Rijn
(1606–1669)

Portrait of Jan Rijcksen and Griet Jans ('The Shipbuilder and his Wife')

Signed and dated 1633
Oil on canvas, 113.8 × 169.8 cm
RCIN 405533

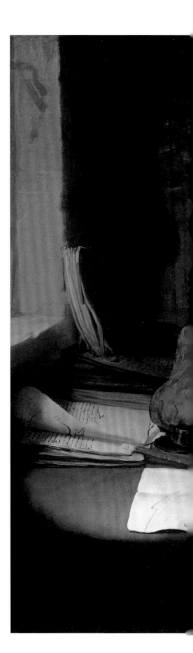

Acquired by George IV in 1811, when Prince Regent

The usual way to depict married couples in Dutch art – seen in the portraits of Nicolaes van Bambeeck and Agatha Bas (see cat. 38 and Fig. 19) – was in two separate paintings, with the husband to the left and sometimes a suggestion of dialogue between the two. Rembrandt conceived this wide-format double portrait as a fusion of two such individual portraits. His originality lies in the contrasts between the figures, she on foot and hurrying into the room, he seated and at rest, and the awkward fact that he has his back to her. Rembrandt imagines that Griet Jans has brought her husband an urgent message – the writing on the paper is deliberately illegible – which he seems reluctant to deal with. The slightly comic relationship between two elderly figures seems to owe something to Rembrandt's earlier depiction of the Biblical couple Tobit and Anna (painted in 1626, and now in the Rijksmuseum, Amsterdam).

36

Rembrandt van Rijn
(1606–1669)

A Rabbi with a Cap

Signed and dated 1635
Oil on panel, 72.6 × 62.3 cm
RCIN 405519

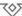

Acquired by George III in 1762 as part of the collection of Joseph Smith, British Consul in Venice

This is a type of painting called a '*tronie*' in Dutch inventories; the word is slang for head (rather like the English 'mug') and in art refers to expressive character heads that are not portraits. In this case the sitter wears the costume of a rabbi, including a velvet mantle, elaborate pectoral ornament hanging around his neck and a black kippah with silver tassels. The portrait may record a member of the large Jewish community in Amsterdam in the seventeenth century, but it is more likely that Rembrandt is using his sitter as a model for a character that might reappear in one of his many Biblical scenes.

Heads of this type by Rembrandt are much more rapidly, freely and expressively painted than his commissioned portraits, as can be seen by comparison with the features of Jan Rijcksen (cat. 35), painted only two years previously. His etchings at this time have a gnarled treatment of form and tangled pattern of lines. The painting of the face here exhibits something comparable, especially the way in which the artist has scratched into the wet paint of the beard with the stick end of his brush.

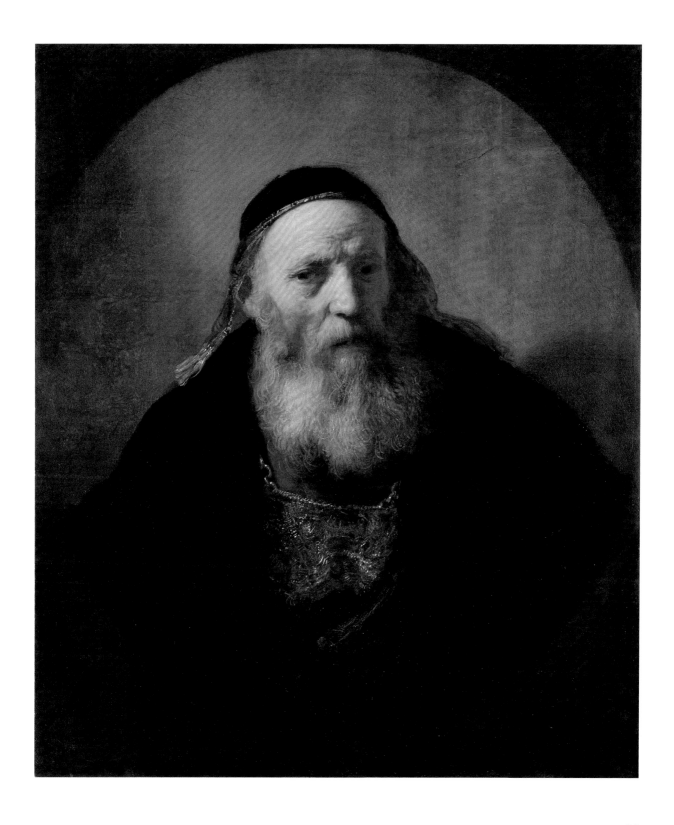

37

Rembrandt van Rijn
(1606–1669)

Christ and St Mary Magdalen at the Tomb

Signed and dated 1638
Oil on panel, 61.0 × 50.0 cm
RCIN 404816

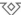

Acquired by George IV in 1819, when Prince Regent

In St John's Gospel (20:11–18) Mary Magdalen finds Christ's empty tomb before dawn and, having told the disciples, returns to mourn the stolen body. In the empty sepulchre she sees angels at the head and the foot of the place where Christ lay. She then turns to a figure standing nearby, who asks her why she is weeping. This figure is Jesus. Supposing him to be a gardener, she asks if he has taken the body and where he has laid it. Jesus then calls her by her name; she turns again and recognises her Lord. He forbids her to touch him, but asks her to go to the disciples and say, 'I ascend unto my Father'.

Rembrandt follows the text closely, mindful of the time of day, the position of the angels and the reference to Mary turning in order to see Christ. The scene even seems somewhat over-literal: the angels are apparently resting after their heavy lifting; Christ has a gardener's spade, sun hat and pruning knife. Rembrandt also expresses the theological meaning: the risen Christ, at the exact centre of the panel, offers redemption to the sinner who turns to the light.

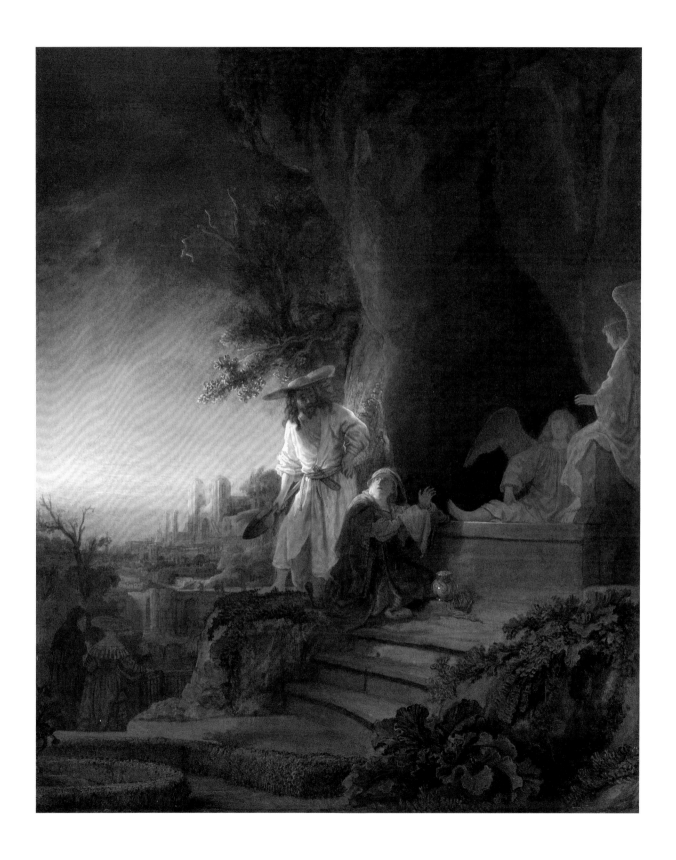

101

38

Rembrandt van Rijn
(1606–1669)

Portrait of Agatha Bas ('Lady with a Fan')

Signed and dated 1641
Oil on canvas, 105.4 × 83.9 cm
RCIN 405352

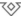

Acquired by George IV in 1819, when Prince Regent

This is one of a pair of portraits painted in 1641, depicting the 30-year-old Agatha Bas (1611–58) and her 45-year-old husband, Nicolaes van Bambeeck (1596–1661), whom she married in 1638. The portrait of Nicolaes (Fig. 19) would have hung to the left, facing his wife's; both figures are seen through a fictive ebony frame and seem to extend over the ledge and project from the false space of the painting into the 'real' space of the viewer.

Artists are generally admired for a certain easy looseness of design. At about this date Rembrandt experimented with its opposite: figures are arranged in strict profile or frontal view, as here, their costume built up like sculpture from thick paint, which creates a stiff frontal effect. The image as a whole is not stiff – many textures are soft and the light is mysterious throughout – but there is definitely some starch in the design.

19
Rembrandt van Rijn, *Portrait of Nicolaes van Bambeeck*, 1641, oil on canvas, 105.5 × 84.0 cm, Royal Museums of Fine Arts of Belgium, Brussels, inv. no. 155

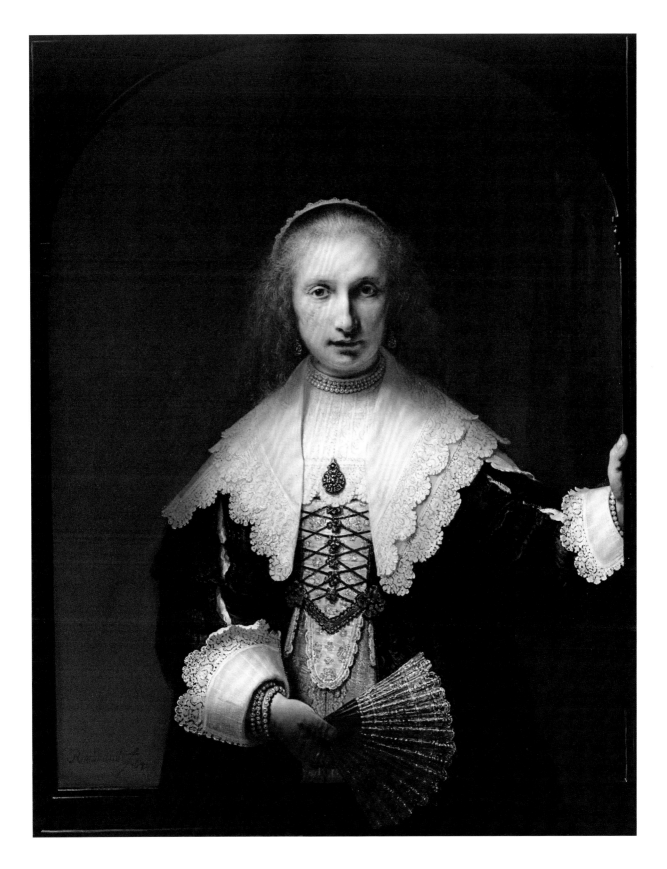

103

39

Rembrandt van Rijn
(1606–1669)

Self-Portrait in a Flat Cap

Signed and dated 1642
Oil on panel, 70.3 × 58.8 cm
RCIN 404120

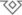

Acquired by George IV in 1814, when Prince Regent, from Sir Thomas Baring as part of a group of 86 important Dutch and Flemish paintings

Rembrandt's self-portraits formed an important part of what today would be called the artist's 'brand'. The first group of Rembrandt paintings to leave Holland were three sent to Charles I in 1630, which included a *Self-Portrait* (now in the Walker Art Gallery, Liverpool). There was a Rembrandt self-portrait (now lost) in Charles II's collection and another came with the Consul Smith purchase (probably the *Young Man wearing a Turban*, in the Royal Collection). The present painting acquired by the future George IV was the finest of the type, but certainly not the first.

The popularity of Rembrandt's self-portraits presumably reflected a desire to honour a successful artist, rather as Charles I acquired that of Rubens (cat. 28). There seems also to have been an interest in exploring some more inward expression of a man's being, in the manner of an autobiography. In his mid-career self-portraits, like this one, Rembrandt shows himself as a fashionable and successful artist, but with an intensity of exploration of the details of his 'lived-in' face which is quite unlike the suave self-presentation of Rubens. The comparison with cat. 28 is especially interesting as Rubens was ten years older than Rembrandt at the time of painting.

40

David Teniers the Younger
(1610–1690)

Fishermen on the Sea Shore

c.1638
Oil on canvas, 92.8 × 123.1 cm
RCIN 405348

Acquired by George IV in 1812, when Prince Regent

This is a typical example of a men-at-work style of landscape
in the tradition of Pieter Bruegel the Elder. Instead of the
labours of the months, we see here the labours of the sea,
with a fisherman and his boy selling their catch. Everything
suggests that fishing is a tough profession, with leaden skies,
desolate shoreline and meagre haul. The tower (presumably
a form of lighthouse), the break in the clouds and segment
of a rainbow perhaps convey the idea that this is true of life
in general but that Faith and Hope can offer consolation.

The sea, land and sky here all run into one another and
seem to be painted in the same grey colour (faintly tinged
with yellow and brown on the shore) and with similar
patterns of the brush. Only dramatic touches of red and
green in the clothes of the fishermen break up the overcast
landscape.

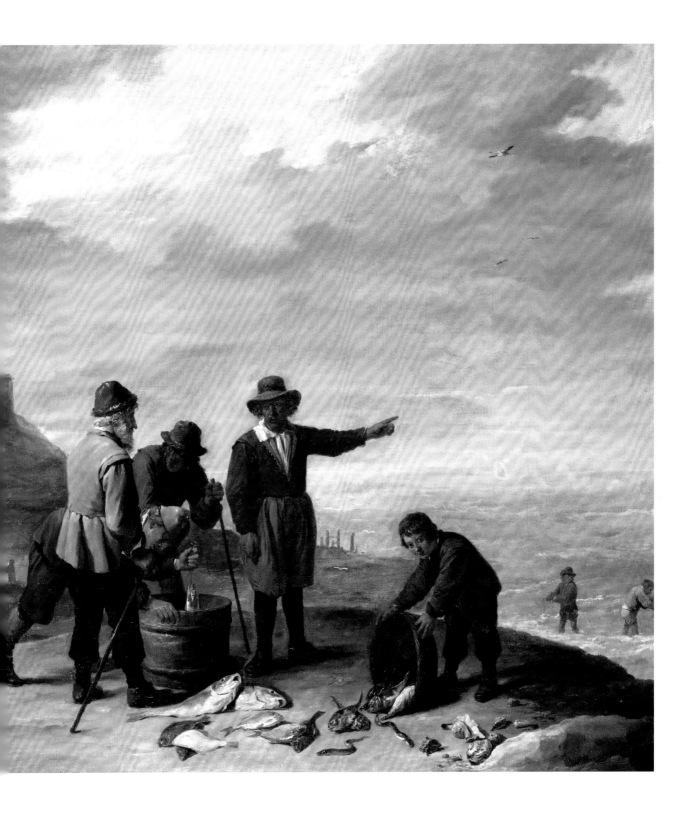

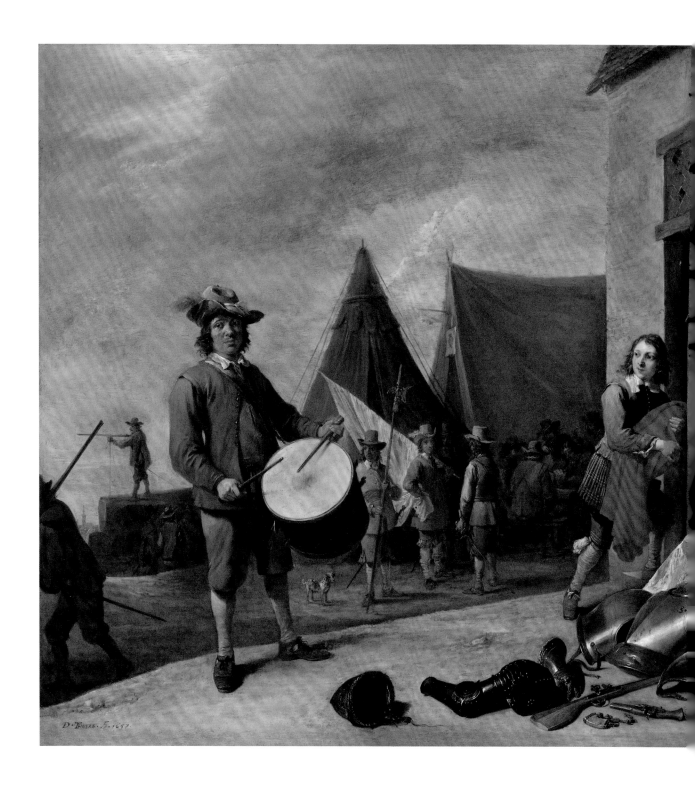

41

David Teniers the Younger
(1610–1690)

The Drummer

Signed and dated 1647
Oil on copper, 49.5 × 65.3 cm
RCIN 406577

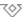

Acquired by George IV in 1803, when Prince of Wales

Teniers painted many military scenes during the time that his patron, Archduke Leopold William (1614–62), was Governor of the Southern Netherlands (1647–56). This one dates from the final year of the Eighty Years' War, which was concluded by the Peace of Westphalia in 1648. The regimental banner to the right bears the orange, blue and white of the Dutch Republic and is presumably therefore intended as a captured trophy of victory, along with the arms and armour that surround it.

Flemish paintings of this date sometimes have an encyclopaedic character. This one appears more like a catalogue of militaria than a depiction of a real camp. We see a guard room, tents, musket practice, a card game and regimental mascot, as well as the still life of paraphernalia in the lower right-hand corner. We even seem to hear the drum – the characteristic sound of the camp.

42

David Teniers the Younger
(1610–1690)

A Kermis on St George's Day

Signed and dated 1649
Oil on canvas, 79.7 × 88.7 cm
RCIN 405952

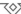

Acquired by George IV in 1821

This painted comedy has a religious meaning. The Feast of St George (whose image appears on the banner hanging from the tavern window) was celebrated on 23 April by a *kermis*, a service (the word means 'church-mass') followed by a day of festivities. We see the church in the background to the right, beyond a crowd separating two brawlers, in a satirical comment on the neglect of its message of peace. If this demonstrates the sin of Anger, it is easy to find Sloth, Gluttony and Lust among the revellers in the foreground. These are vices common to all ranks in society; there is less call here for the vices of the quality – Pride, Avarice or Envy. Instead we see universal human folly viewed comically and even indulgently, especially by the wise old bird with the apron leaning on his staff.

There may also be a political message. It is tempting to see this picture, painted a year after the conclusion in 1648 of the Eighty Years' War in the Netherlands, as a celebration of peace, just as *The Drummer* of two years earlier (cat. 41) seems to glorify conflict.

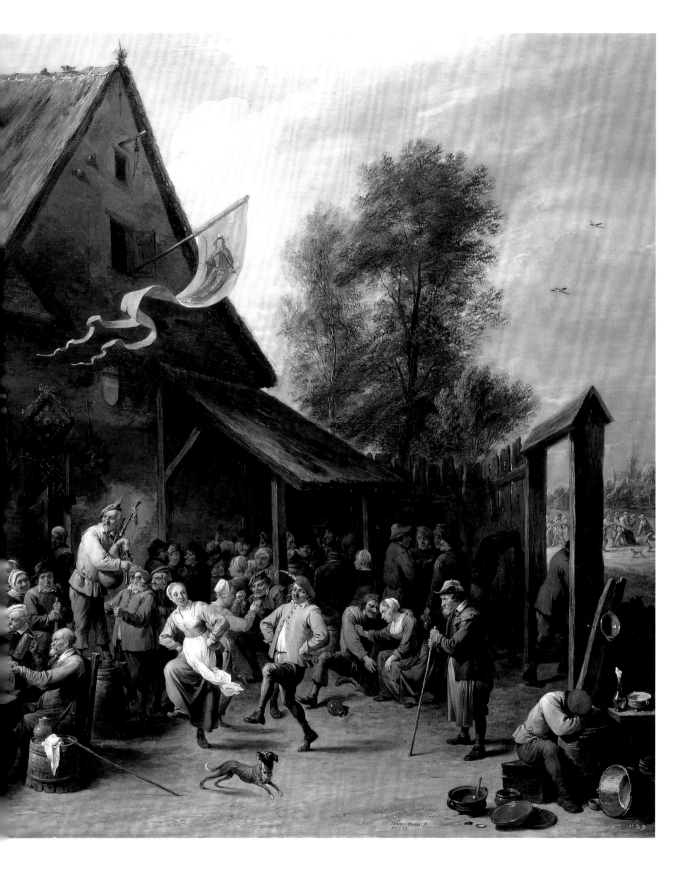

43

David Teniers the Younger
(1610–1690)

Interior of a Farmhouse with Figures ('The Stolen Kiss')

*c.*1660
Oil on canvas, 71.6 × 87.4 cm
RCIN 405342

Acquired by Frederick, Prince of Wales, in the 1740s

In a barn attached to a house a young lad is caught by a farmer misbehaving with his elder daughter whilst his wife tends the cows in the background. The scene is filled with suggestive details – the copper vessel plugged with straw, the ripe vegetables, the hare slung up and the knife held by the farmer, its sheath dangling between his legs. This kind of *commedia rusticana* was exactly what eighteenth-century aristocratic patrons sought in Teniers.

The painting was acquired by Frederick, Prince of Wales, who commissioned its splendid rococo frame from Samuel Pearse and had the work engraved by Thomas Major as 'The Jealous Husband'.

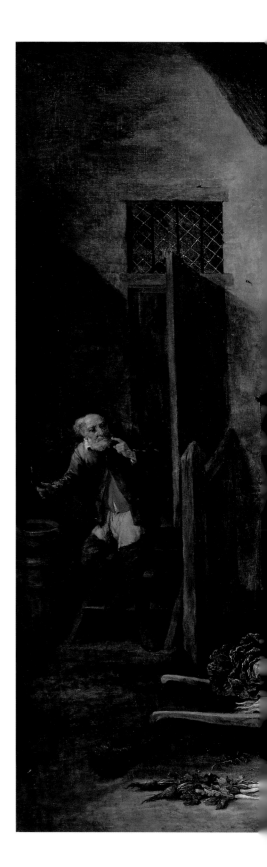

44

Hendrick Pot
(*c.1585–1657*)

Charles I, Henrietta Maria and Charles, Prince of Wales

*c.*1632
Oil on panel, 47.3 × 59.7 cm
RCIN 405541

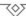

Acquired by George IV in 1814, when Prince Regent, from
Sir Thomas Baring (see cat. 39)

Although presumably commissioned by Charles I, there is no record of this charming conversation piece in his collection; this was one of a small group of George IV's acquisitions that reflect his admiration for the taste of his ancestor.

Portraits of married couples, whether pairs or in a single composition (see cats 35 and 38), place the husband on the right-hand side (left as we look at it). Cat. 44 and the *Anthoine Family* (cat. 46) belong to a handful of family group portraits in which the wife is given this prominent position, always in her role as mother. In this case Henrietta Maria is enthroned on a dais with her son, the future Charles II, seated beside her on the table. The King seems to have set his crown and sceptre (and even his hat) on the table before her. This gallantry towards his wife is an important strand in Charles I's iconography and is usually associated with the Stuart advocacy of peace. Here, an olive branch lies next to the sceptre, its leaves strewn over the floor.

45

Barent Graat
(1628–1709)

A Family Group

Signed and dated 1658
Oil on canvas, 57.9 × 67.4 cm
RCIN 405341

Acquired by George IV in 1811, when Prince Regent

We see here a prosperous bourgeois family, a scene charac-
teristic of Graat's small-scale portraits. The elderly parents
are 'enthroned' at a table in the centre – he is the only one
to wear his hat, she sits on a chair with arms (a subtle status
indicator at this time). They wear old-fashioned clothes,
differentiating them from their grown-up children, who are
disposed around them. The eldest son slouches nonchalantly
to the left (on a chair without arms), holding a pendant of
some kind in his left hand. A younger son standing behind
his father wears petticoat breeches – the latest fashion.
Their daughter wears a low-cut bodice, in contrast to the
high-necked overgown her mother sports, specifically
reserved for married women. The table is covered with a
Turkish rug, with a wine glass on a silver tray – a servant boy
brings a jug and another glass. All the details of costume and
furnishing would seem to be accurately recorded; the setting
is wholly imaginary, with an Italianate portico and landscape
background.

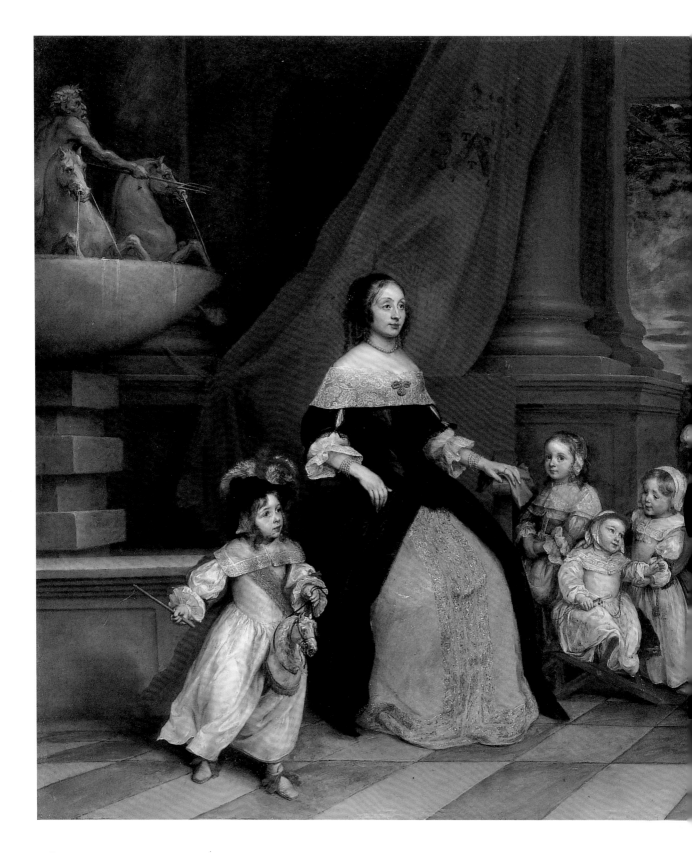

46

Gonzales Coques
(1614–1684)

The Family of Jan-Baptista Anthoine

Signed and dated 1664
Oil on copper, 56.5 × 73.8 cm
RCIN 405339

Acquired by George IV in 1826

Edgar Degas (1834–1917) advised artists to 'create falsely and add a touch from nature'. No such advice dates from the seventeenth century because it would never have occurred to anyone to do otherwise. The setting here is entirely false ('imaginary' might be a fairer way of putting it): the Neptune fountain, the bust of Homer, the banner with the sitter's coat of arms, the open, paved terrace with monumental columns, fantastical pergola and view of an estate beyond. The arrangement of the figures is contrived: the enthroned wife, gallant husband (standing to her left with doffed hat), eldest son riding a hobby horse and group of affectionate younger children. All the figures are posed and described with 'art', with the studied elegance and flourish of van Dyck. Coques may have created falsely, but his touches from nature are sublime. We see them in the details of the costume, the freshness with which the figures are painted, the liveliness of their movements and the animation of their expressions.

47

Gerrit Dou
(1613–1675)

A Girl Chopping Onions

Signed and dated 1646
Oil on panel, 20.8 × 16.9 cm
RCIN 406358

*Acquired by George IV in 1814, when Prince Regent, from
Sir Thomas Baring (see cat. 39)*

Rembrandt trained Gerrit Dou in his studio in Leiden, and
many others, including Nicolaes Maes (cat. 49), at his studio
in Amsterdam. Dou himself trained a cohort of painters,
including Godfried Schalcken (cat. 55). Whether at first or
second hand, Rembrandt's influence was felt by most artists
in the Dutch Golden Age; it resulted in an extraordinary
range of ideas, styles and techniques. Dou and his followers
were famous for their minute detail, which is why they were
often referred to as the Leiden 'fine painters'. In this tiny
panel we seem to be able to see every hair and every feather
as well as admire the intricate construction of the bird cage.

Though painted long after Rembrandt's departure from
Leiden, this work retains his muted colour range, with a very
narrow spectrum dominated by grey, intensified to blue on
the girl's dress. Colour is suppressed or harmonised in order
to accentuate the effect of light. In this Dou was inspired by
Rembrandt paintings, like cat. 35, with a window to the left
filling the scene with natural daylight. Dou's light is brighter
and his shadows less mysterious.

48

Gerrit Dou
(1613–1675)

The Grocer's Shop

Signed and dated 1672
Oil on panel, 41.5 × 32.0 cm
RCIN 405542

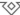

Acquired by George IV in 1817, when Prince Regent

Rembrandt instilled in his followers a love of illusionism, seen here in the fictive stone arch, with a relief copied from one by the Flemish sculptor François Duquesnoy (1597–1643). As with the portrait of Agatha Bas (cat. 38), we assume the arch to be flush with the picture frame, which creates the illusion of objects advancing into our space: a bird-cage, poppy-heads, curled-up paper, a cushion-like cake and terracotta pot resting on a stool. The pot contains a pink. The plant is probably included to insinuate in our minds the thought that the scene is so real we can smell it. In *A Girl Chopping Onions* (cat. 47) a similar function is performed by the pot tipping over the front edge of the table and the onions that seem to make our eyes water.

In this later work Dou's colours are brighter and his subject more genteel. In both works it is uncertain whether any meaning is intended beyond the simple recording of everyday activities.

123

49

Nicolaes Maes
(1634–1693)

The Listening Housewife

Signed and dated 1655
Oil on panel, 74.9 × 60.5 cm
RCIN 405535

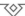

Acquired by George IV in 1811, when Prince of Wales

The mistress of the house, with keys at her waist, descends a precipitous spiral staircase, of a type peculiar to Holland at this date, in order to surprise a servant who is misbehaving with unwanted guests in a lower room. She seems to be taking us into her confidence as she looks straight at us, holding her finger to her mouth, making sure we do not give her away. The eavesdropper was a popular contemporary literary figure, whose role was often to uncover immorality and sinfulness.

The muted colours, raking light and palpable shadows are all devices learned from Rembrandt; the below-stairs group even resembles one of his Nativity scenes (somewhat inappropriately). A series of enigmatic single-figure paintings of serving girls were created within Rembrandt's studio between 1645 and 1651 (which can now be found at the Dulwich Picture Gallery, London, Art Institute of Chicago and the National Gallery of Art, Washington, DC). Though in a narrative of sorts, Maes' *Listening Housewife* relates to this group, in the frontality and isolation of the figure and engagement with the spectator.

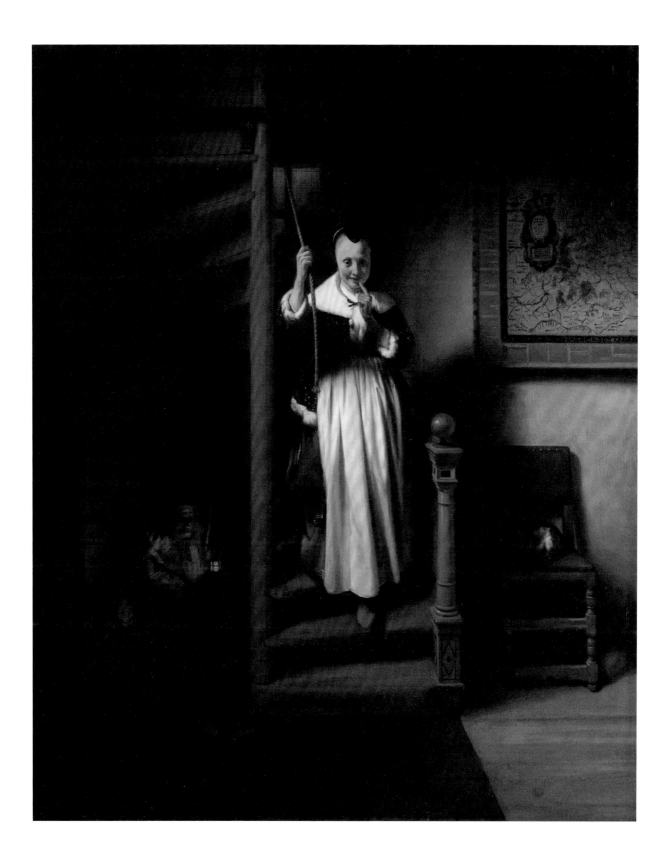

50

Pieter de Hooch
(1629–1684)

A Courtyard in Delft at Evening: A Woman Spinning

1657
Oil on canvas, 69.3 × 53.8 cm
RCIN 405331

Acquired by George IV in 1829

It seems as if Nicolaes Maes (cat. 49) has *staged* a scene of everyday life and that de Hooch has *encountered* one. Maes is in good company: Dou, Schalcken and Adriaen van Ostade are all essentially stage-managers. The only other artist with de Hooch's brand of artlessness was Vermeer. De Hooch and Vermeer avoid the usual contrivances. In most genre paintings light passes across the front of the scene, so that it becomes darker the further back you look. In this courtyard the light is brightest in the sky and the middle ground, in an effect of direct sunshine previously unknown in art. In de Hooch's *Cardplayers* (cat. 51) it enters from a courtyard at the back of the room. In both these paintings the figures are disposed as if unaware that they have an audience; in both we can imagine recording the scene with a completely different 'camera angle'.

This extra level of realism must especially have struck contemporaries who would have been able to recognise familiar Delft landmarks – the tower of the Town Hall to the right and the spire of the New Church peeping over the red-brick gable of the house opposite.

51

Pieter de Hooch
(1629–1684)

Cardplayers in a Sunlit Room

Signed and dated 1658
Oil on canvas, 77.3 × 67.3 cm
RCIN 405951

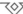

Acquired by George IV in 1825

This painting has the freshness of perspective discussed in cat. 50, which, in the words of the Regency art dealer L.J. Nieuwenhuys, give it an effect that is 'perfectly illusive'. Its subject is more familiar: overdressed wastrels in a pub drinking and gambling the day through. Their stylishness appears somewhat self-conscious, complete with natural long hair, fashionable before wigs became prevalent a decade later. There is a hint of connivance between the two men to the right, who make eye contact as if they are cheating the woman. A servant, holding a jug and set of pipes, walks wearily across the courtyard, as if this is not the first time she has had to do this.

The comedy is familiar but the relationship between figures and setting is fundamentally 're-balanced'. The most prominent figure sits with his back to us. Instead it is the space that commands our attention, and the light reflecting off the plaster wall, playing over the floor tiles, bringing out every variation in their colour and surface.

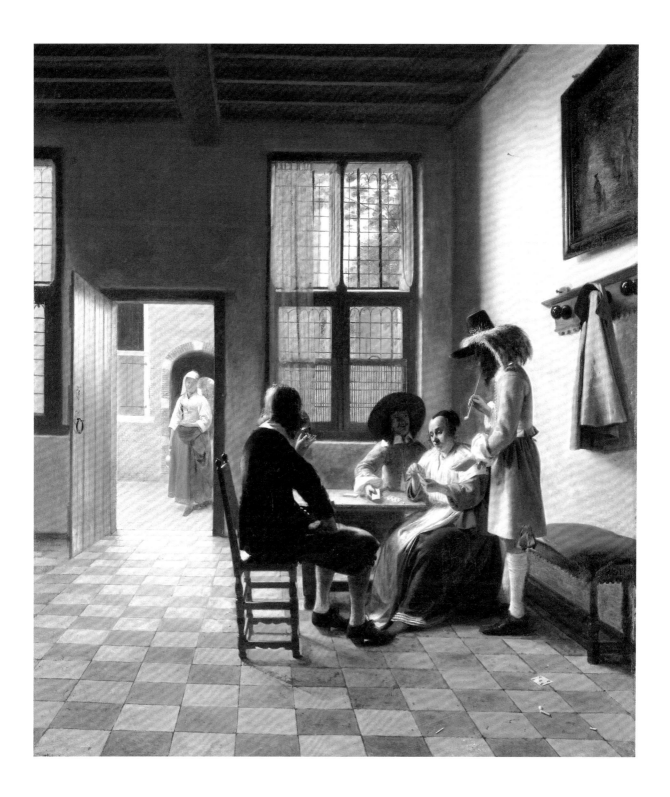

Johannes Vermeer
(1632–1675)

A Lady at the Virginals with a Gentleman ('The Music Lesson')

Early 1660s
Oil on canvas, 74.1 × 64.6 cm
RCIN 405346

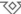

Acquired by George III in 1762 as part of the collection of Joseph Smith, British Consul in Venice

Traditional academic theory taught artists to choose an elevated subject (the human figure), to imitate it but at the same time to idealise it by reference to their study of drawing and of Antique sculpture. The appropriate classical architecture provided whatever setting was required. Vermeer, however, chooses an ordinary (if elite) subject and imitates it with obvious and astonishing fidelity – of perspective, distribution of tone and artless *mise en scène*. His reputation is based on this, but also on the perception that he discovers a beauty in this ordinariness – in the fall of light on a simple plaster wall or the smooth volume of a ceramic jug. We feel that he idealises as much as Raphael but in ways that are more difficult to pin down. This may reflect the limits of European artistic theory – the fact, for example, that Vermeer's contemporaries had no word for *feng shui*.

Vermeer's ideal may be found in his use of intensified colour – wood is yellow, shadows are blue – which gives to every surface the quality of a precious material. It may also be found in his pattern of shapes and lucidly spaced intervals and in the arrangement of horizontal and vertical lines. Most of all it is found in the way in which light and space seem to be palpable entities – not means by which objects are revealed, but things in their own right.

53

Jan Steen
(1626–1679)

A Woman at her Toilet

Signed and dated 1663
Oil on panel, 65.8 × 53.0 cm
RCIN 404804

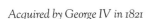

Acquired by George IV in 1821

Fictive stone arches are common in Dutch painting (see
cat. 48), but this elaborate architectural frame – like a church
door – is quite unique. It has an angel carved on the arch and
a still life on the threshold, comprising a lute, a musical score
and a skull (overgrown with ivy). The message is clear: earthly
pleasures are transient, and we should look to heaven for
lasting felicity. The arch has a simple wooden door, which
opens onto a bedroom, where a young woman undresses,
surrounded by evidence of luxury and worldliness. This
scene repeats the same message.

One aspect of the luxury of the bedroom that we may
now take for granted is its brilliant cool light, obviously
coming from large windows to the left. Such an expanse
of glass would have been as expensive as the marble floor.
The skill with which this effect is painted demonstrates an
awareness of de Hooch and Vermeer, especially the way in
which our view moves from a dark foreground to a luminous
middle ground.

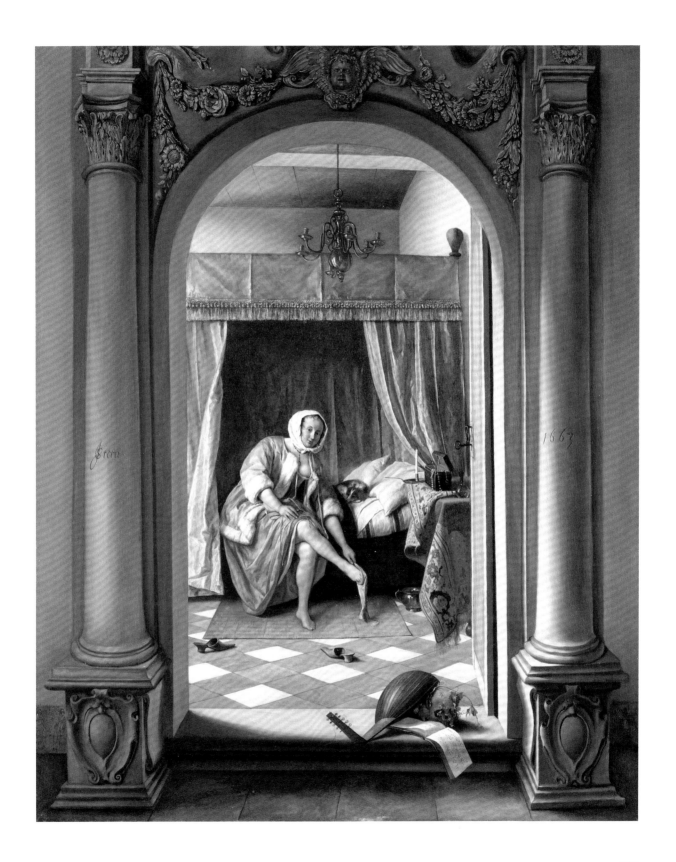

54

Jan Steen
(1626–1679)

Interior of a Tavern, with Cardplayers and a Violin Player

c.1665
Oil on canvas, 81.9 × 70.6 cm
RCIN 405825

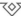

Acquired by George IV in 1818, when Prince Regent

This is Steen at his best and most characteristic. It is a tavern scene of broad comedy, with every pleasure and vice explored: drinking, music, dancing, gambling and seduction. The woman to the right proudly shows us her trump card – the ace of hearts – suggesting that Love is her game. To the far left Steen paints a self-portrait, apparently insinuating himself with the woman seated in front of him, guffawing all the time.

The painting of the figures is sketchy and expressive, but other details are rendered with care and astonishing realism. In particular the immediate foreground is painted with the kind of illusionism seen in the work of Dou or Maes – the violinist's legs, the table with projecting knife-handle, the other with the white cloth draped over its corner, the foot warmer and pewter jug with its minutely observed reflections. One of the purposes of comedy is to make us recognise and understand the world around us. Steen wants us to experience the tavern, to feel and touch its pleasures as well as laugh at its follies.

55

Godfried Schalcken
(1643–1706)

The Game of 'Lady Come into the Garden'

c.1668
Oil on panel, 63.5 × 49.5 cm
RCIN 405343

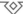

Acquired by George IV in 1803, when Prince of Wales

According to Schalcken's pupil and biographer, Arnold Houbraken (1660–1719), this unusual composition depicts 'a certain game that the youngsters of Dordrecht would commonly play at that time ... called "Lady come into the Garden". He portrayed himself dressed in his shirtsleeves and underwear and seated against the lap of a girl. The other faces are also portraits, and were recognized by all at the time.' The game presumably involves shedding clothes every time you fail in some humorous task. It is obvious from Houbraken's description that this is a scene of innocent high jinks, but surely one with overtones of love and courtship. The artist's gesture of resignation would seem to imply something like, 'I surrender to Love'.

Schalcken was a pupil of Gerrit Dou (cats 47 and 48), from whom he learned how to depict fine stuffs in minute detail and with a natural glow of light. In this case the source would seem to be a chandelier hanging in front of the picture plane, casting a warm light over the foreground, while the background rapidly sinks into darkness.

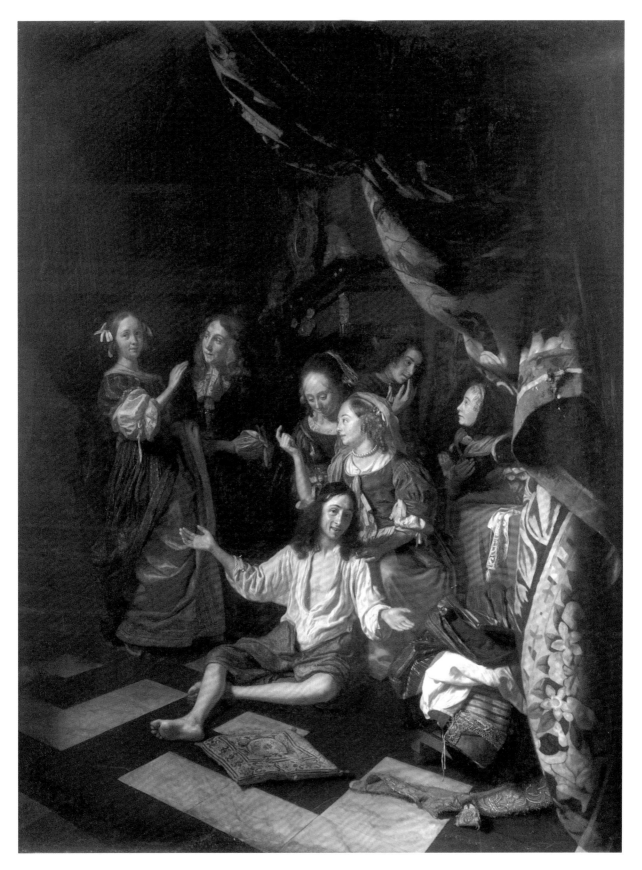

56

Adriaen van Ostade
(1610–1685)

The Interior of a
Peasant's Cottage

Signed and dated 1668
Oil on panel, 49.0 × 41.2 cm
RCIN 404814

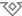

Acquired by George IV in 1811, when Prince Regent

Adriaen van Ostade spent his career depicting low-life interiors that often combine the characteristics of cottages and taverns. This spacious room with its large windows, flooding the scene with natural light, seems at odds with the modest inhabitants. Ostade has been influenced by Gerrit Dou's later work (cat. 48), not only in this use of light, but in the conception of a painting as an artificial stage that may be filled with as many objects as possible. The idea seems to be to present not so much a glimpse of peasant life as a systematic catalogue of all its potential elements, rather as in Teniers' *The Drummer* (cat. 41).

This picture belongs to a significant group of genre paintings made in the second half of the seventeenth century that show a wholly positive image of Dutch peasantry. This family may be slightly absurd in their appearance, but they are clearly fortunate in their prosperity and virtuous in their behaviour.

57

Jan Both
(c.1618–1652)

Landscape with St Philip
Baptising the Eunuch

1640s
Oil on canvas, 128.2 × 161.2 cm
RCIN 405544

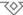

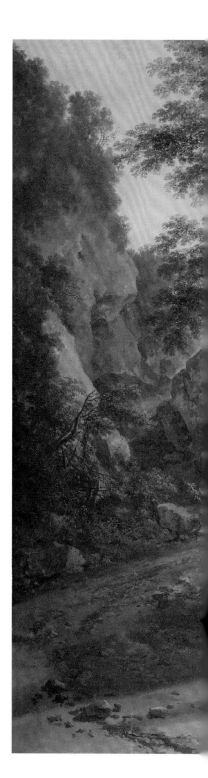

Acquired by George IV in 1811, when Prince Regent

Jan Both was working in Rome between 1638 and 1642; in 1640 he contributed, along with Claude Lorrain (cats 15–17), to a series of ambitious religious landscapes for Philip IV of Spain. This painting is conceived in a similar spirit as an epic landscape supporting a narrative. The Acts of the Apostles (8:26–39) tell how St Philip shared a ride with a noble eunuch in the employ of Queen Candace and persuaded him that Christ was the one whose coming had been foretold by Isaiah. The eunuch elected to be baptised at the first opportunity.

The landscape combines a dry mountainous terrain, which might pass for the Holy Land, with a baptismal lake and a winding road suggestive of the journey shared by St Philip and his convert. Above all it is marked by an all-pervading evening light, striking the figures, saturating the foliage and hanging in the mist over the distance. This is surely intended to be understood as the light of divine revelation.

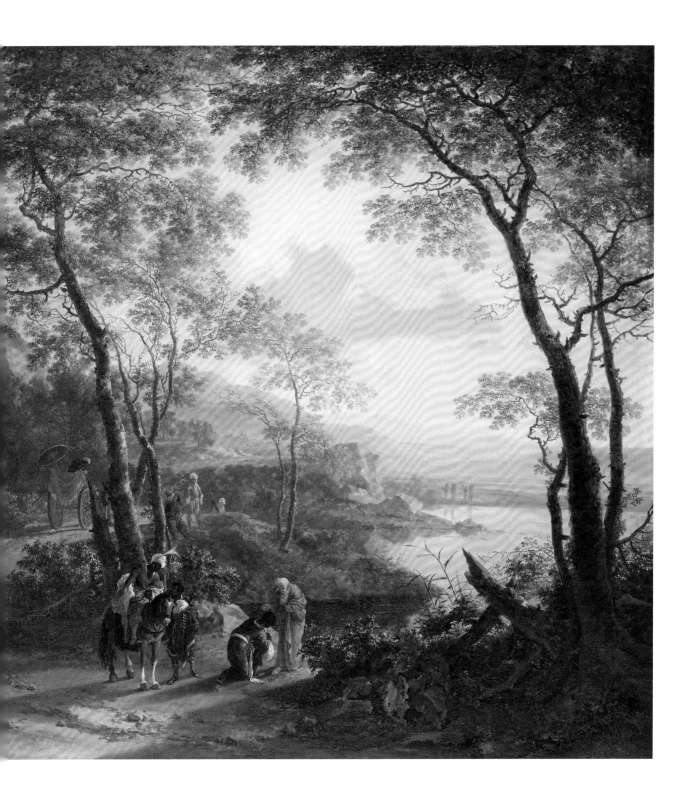

58

Paulus Potter
(1625–1654)

A Young Bull and Two Cows in a Meadow

Signed and dated 1649
Oil on panel, 70.7 × 63.0 cm
RCIN 404585

Acquired by George IV in 1814, when Prince Regent, as part of the collection of Sir Thomas Baring (see cat. 39)

We have already seen two types of landscape created during the seventeenth century: the classical style developed in Rome by Claude Lorrain (cats 15–17) and adopted by Gaspard Dughet (cat. 18) and Jan Both (cat. 57); and the tradition of Pieter Bruegel the Elder, seen in the work of Rubens (cats 25–27) and Teniers (cat. 40). This Dutch landscape offers something different. Previous landscape compositions allow the viewer to survey the scene, often with a God-like perspective; this one puts the viewer in the scene.

The motif of a family of cattle is similar to that in Rubens' *'The Farm at Laken'* (cat. 25) and may indeed have a comparable meaning. The bulls in both pictures seem to symbolise the land upon which they stand, and which, in this case, they seem ready to defend against invaders. It is our relation to the animals that differs. In Potter's painting the viewer has a new sense of perspectival alignment: the land is seen through the bull's legs, the clearing storm takes place over his shoulders. This accompanies a more direct engagement with the subject of a menacing animal looming over us.

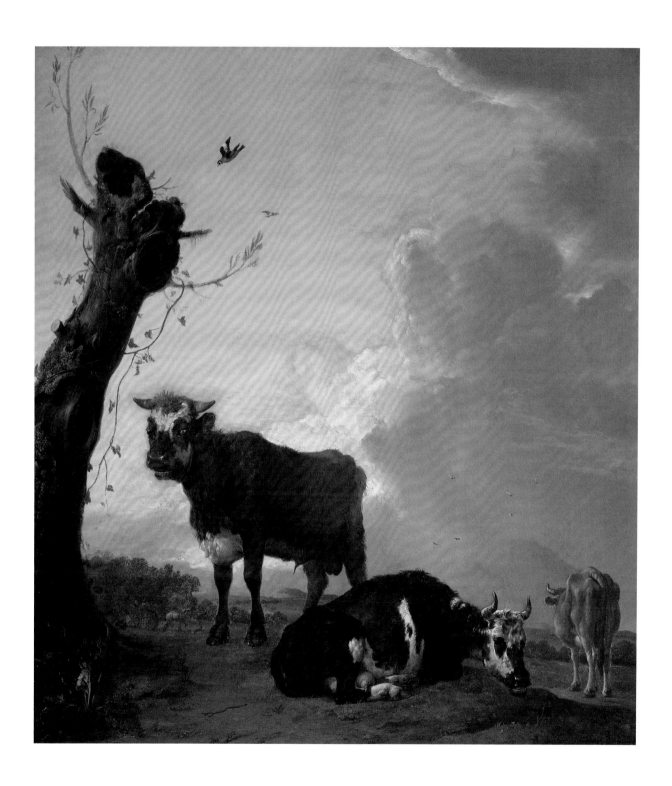

59

Paulus Potter
(1625–1654)

Two Sportsmen
Outside an Inn

Signed and dated 1651
Oil on panel, 53.1 × 43.8 cm
RCIN 400942

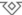

Acquired by George IV in 1811, when Prince Regent

Hunting often takes members of the elite out of their familiar environment into some sort of wilderness. Here they are liable to strange encounters, whether miracles as recounted in the legend of St Hubert, or insights into the life of the people as in Turgenev's *A Sportsman's Sketches* of 1852. The pair of cavaliers here, a nobleman in red with his huntsman in black, have ventured into the wild lands of the Dutch Republic, where canals and cultivation give way to inhospitable dunes. They have found a public house – identified as such by the wreath over the door – which seems little more than a barn shared by men and pigs. This is a comedy of mismatched classes: a barefoot stable-boy struggling with the gentleman's mount, dogs sniffing each other suspiciously, the inn-keeper mopping his brow in exasperation.

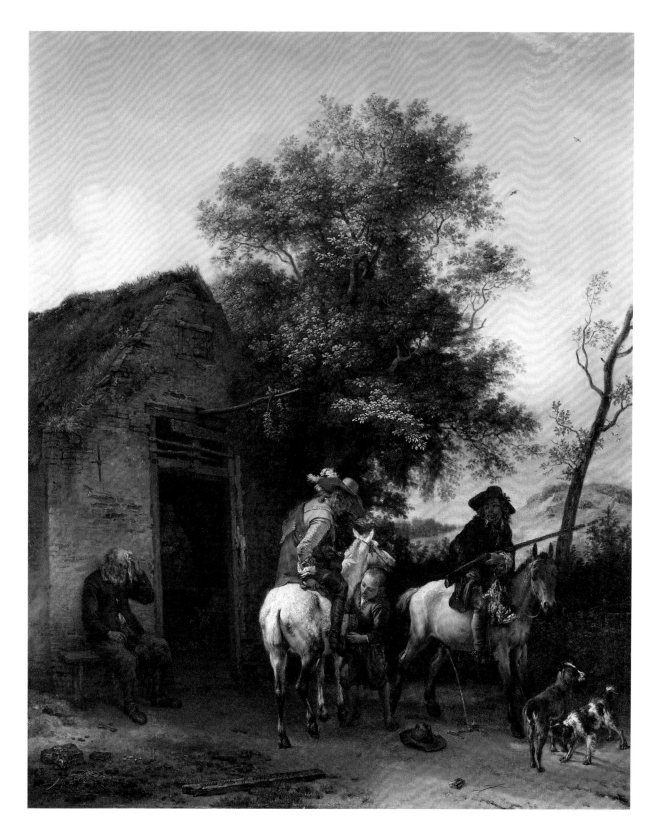

145

60

Jacob van Ruisdael
(c.1628–1682)

Evening Landscape:
A Windmill by a Stream

c.1650
Oil on canvas, 79.1 × 102.4 cm
RCIN 405538

Acquired by George IV in 1810, when Prince of Wales

Jacob van Ruisdael is the least 'chocolate-box' landscape painter in the history of art. The subject of this painting is familiar and hospitable: fields drained by ditches used for bleaching linen, homesteads, a typical small free-standing wooden gate and a slightly old-fashioned 'post mill'. The treatment of these potentially picturesque elements makes them seem grave and threatening. There are no figures with whom we can relate, the foreground is in shadow and the path does not lead the eye into the distance. The day seems blustery, the clouds substantial and the ground lit fitfully as the sunlight breaks through them. The forms of nature seem rough, dark and heavy, made up of spiky or gnarled patterns.

It is this sense of the drama of the ordinary that appealed to John Constable at around the time that this painting entered the Royal Collection. Constable saw this picture when it was lent to the British Institution in 1821, and described it to a friend as 'The beautiful Ruisdael of the "Windmill and log-house", which we admired at the Gallery'.

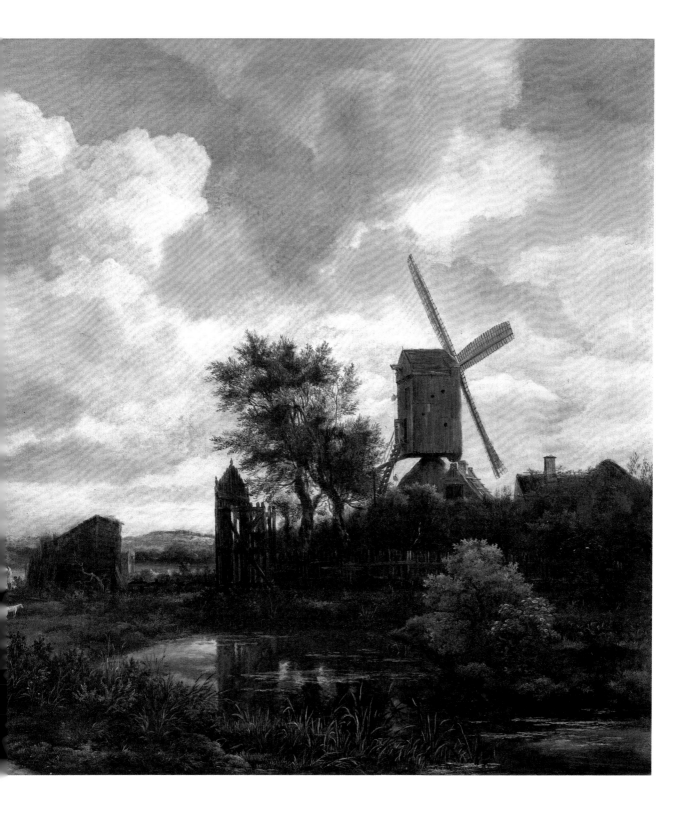

61, 62

Willem van de Velde
the Younger
(1633–1707)

A Calm: A States Yacht under Sail close to the Shore, with many other Vessels

*c.*1655
Oil on panel, 59.8 × 71.5 cm
RCIN 405328

A Calm: A States Yacht, a Barge and many other Vessels under Sail

Signed and dated 1659
Oil on canvas, 61.4 × 71.6 cm
RCIN 407275

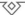

Acquired by George IV in 1814, when Prince Regent, from Sir Thomas Baring (see cat. 39)

These two seascapes were not painted as a pair, though they were acquired together by the future George IV from Sir Thomas Baring and have been treated as such ever since. Both depict what are sometimes called 'naval parades': a crowded range of ships in close proximity in what is probably intended to represent the Dutch inland sea, the Zuider Zee, the route to the major ports of the Republic, including Amsterdam. Each painting contains a States Yacht, with a gilded coat of arms on its stern; this was the transport of major dignitaries, one of whom is being rowed out in cat. 62. The other ships are minor vessels with shallow draft used for coastal waters only. In both paintings an impression is created of density of shipping and therefore of economic activity, and that the humbler vessels enjoy the protection of the Dutch state.

These two pictures represent the high point of Dutch marine painting, with minutely recorded ships brought together in an effect of atmospheric unity. Like many poetic descriptions they draw attention to the way in which the sea seems one with the sky. The horizon is low and the calm surface of the water reflects the sky; even the sails are reminiscent of clouds. The sky has no perspective; these scenes both have a kind of flatness, distance only suggested by scale.

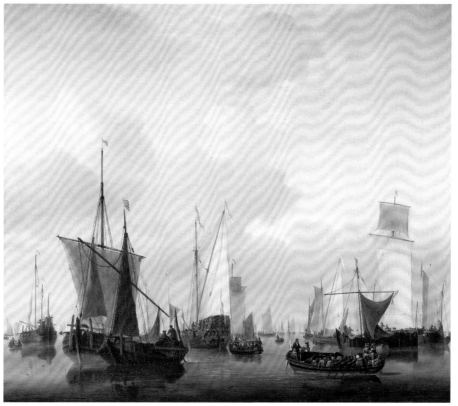

63

Philips Wouwerman
(1619–1668)

The Hayfield

c.1665
Oil on canvas, 66.9 × 79.1 cm
RCIN 405334

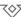

Acquired by George IV in 1811, when Prince Regent

Like Potter's *Sportsmen* (cat. 59), this landscape features two huntsmen, in this case one with a falcon and the other with a lure pole, walking towards us on the right-hand side. This haymaking scene is presented as if through the eyes of an aristocrat or city dweller, like these two, passing through. Our view is partial – the houses and the distance are largely concealed – and yet we see enough to understand the process by which hay is built up in mounds and loaded onto carts or barges. We also enjoy the picturesque incidents: men cooling off in the water and women frolicking in the hay, stuffing it up their skirts.

This painting by Wouwerman was admired by William Seguier when inventorying George IV's collection as 'one of his brilliant and silvery pictures, finished with the greatest care throughout'. This implies a combination of fine detail with a certain softness and atmospheric unity, assuming 'silvery' means shining or glowing in tone as well as white in colour.

64

Adriaen van de Velde
(1636–1672)

A Hawking Party
Setting Out

Signed and dated 1666
Oil on panel, 50.2 × 46.9 cm
RCIN 406966

Acquired by George IV in 1810, when Prince of Wales

This is another hunting scene (the huntsman in the background carries a ring of hawks and is accompanied by hounds) and again we are reminded of the aristocratic nature of the sport. In this case the comedy lies in the pretentious affectation of the plumed *grande dame* riding side-saddle. With the light illuminating her golden bodice and skirt, and the blue feathers in her hair, she takes centre stage.

Adriaen van de Velde's skill lies in the careful way in which he has composed a scene appearing as if an accidental configuration of elements (what we would now call a snapshot), capturing the fleeting gestures of the figures and the rearing horse. We have only to compare this with the way processions in landscape are more schematically disposed by Rubens (cat. 26) or Filippo Lauri (cat. 14). Adriaen was the younger brother of Willem van de Velde (cats 61 and 62); in his work we can see the same low horizon, bright colour, clear detail and polished forms.

153

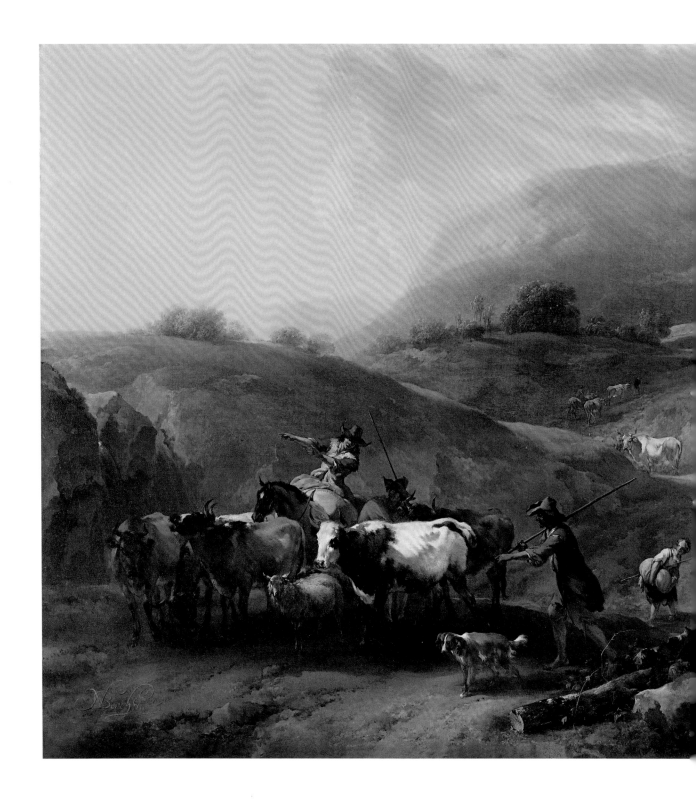

65

Nicolaes Berchem
(1620–1683)

A Mountainous Landscape with Herdsmen Driving Cattle down a Road

Signed and dated 1673
Oil on canvas, 71.8 × 91.4 cm
RCIN 405345

Acquired by George IV in 1814, when Prince Regent, from Sir Thomas Baring (see cat. 39)

Like Jan Both (cat. 57), Berchem was an Italianate landscape painter, though there is no record of his ever having visited Italy. This painting is a typical example of his imaginary evocations of sunbaked mountains and picturesque shepherds. The discipline of perspective, which placed the viewer firmly within the landscapes of Potter and his ilk (cats 58–64), does not apply here. The terrain is laid out in a series of terraces, distinguished from each other by bands of light and dark; the distance is suggested by a transition from brown in the foreground through green to blue in the distance. These are conventions of landscape that had been in operation for the previous century.

George IV acquired this landscape just at the time that taste in Dutch art was changing. A national style that had been admired for its skill was now increasingly valued for its truth. This change of heart left many artists unaffected, but it certainly benefited Ruisdael, de Hooch and Vermeer while fatally damaging the reputations of Berchem and Both. John Constable in particular had an aversion for both artists, even recommending that their works be burned.

Further Reading

Primary sources

Buckingham House c.1790
Inventory of Pictures at Buckingham House, c.1790, RCIN 1112546

Buckingham House 1819
Catalogue of the Pictures at the Late Queen's House, Saint James's Park, 1819, RCIN 1112572

Buckingham Palace 1841
W. Seguier, *Catalogue of Her Majesty's Pictures in Buckingham Palace*, London, 1841, RCIN 1112648

Buckingham Palace 1852
T. Uwins, *Catalogue of the Pictures in Her Majesty's Gallery at Buckingham Palace*, London, 1852, RCIN 1112646

Collection of Manuscripts and Inventories relating to Buckingham House (RA GEO/ADD/19/29)

Queen Victoria's Journals (RA VIC/MAIN/QVJ)

S. von La Roche, *Sophie in London, 1786: Being the Diary of Sophie v. La Roche*, trans. Clare Williams, London, 1933

J.D. Passavant, *Tour of a German Artist in England*, I, London, 1836

W.H. Pyne, *The History of the Royal Residences of Windsor Castle, St James's Palace, Carlton House, Kensington Palace, Hampton Court, Buckingham House, and Frogmore*, London, 1819

G. Vertue, 'Autobiography', *The Volume of the Walpole Society*, 18 (*The Notebooks of George Vertue. Part I*), 1929–30, pp. 1–14

G.F. Waagen, *Works of Art and Artists in England*, II, London, 1838

H. Walpole, *Journals of Visits to Country Seats*, published in P. Toynbee, 'Horace Walpole's Journals of Visits to Country Seats, &c.', *The Volume of the Walpole Society*, 16, 1927–8, pp. 9–80

Printed sources

A. Jameson, *A Handbook to the Public Galleries of Art in and near London*, 2 vols, London, 1842

A. Jameson, *Companion to the Most Celebrated Private Galleries of Art in London*, London, 1844

Secondary Sources
Artistic Theory

G.P. Bellori, *The Lives of the Modern Painters, Sculptors and Architects*, trans. A. Sedgwick Wohl and H. Wohl, Cambridge, 2005

Leonardo on Painting, ed. and trans. M. Kemp and M. Walker, New Haven and London, 1989

J. Montague, *The Expression of the Passions: The Origin and Influence of Charles Le Brun's 'Conférence sur l'expression générale et particulière'*, New Haven, 1994

R. de Piles, *Cours de peinture par principes*, Paris, 1708

Sir J. Reynolds, *Discourses on Art*, ed. R.R. Wark, 3rd edn, New Haven, 1997

G. Vasari, *Lives of the Painters, Sculptors and Architects*, ed. D. Ekserdjian, trans. G. du C. de Vere, 2 vols, New York and Toronto, 1996

History

S. Avery-Quash and K. Retford (eds), *The Georgian London Townhouse*, London, 2019

H. Clifford Smith, *Buckingham Palace: Its Furniture, Decoration and History*, London, 1931

H. Colvin (ed.), *The History of the King's Works*, 6 vols, London, 1963–73

B. Dolman, 'From a royal residence to a royal collection: the State Apartments at Hampton Court Palace, 1737–1838', *Journal of the History of Collections*, 30, no. 2, 2018, pp. 217–33

M. Levey, *The Later Italian Pictures in the Collection of Her Majesty The Queen*, 2nd edn, London, 1991

O. Millar, *The Tudor, Stuart and Early Georgian Pictures in the Collection of Her Majesty The Queen*, 2 vols, London, 1963

O. Millar, G. de Bellaigue and J. Harris, *Buckingham Palace*, London, 1968

C. Noble, 'Fashion in the gallery: the Picture Gallery's changing hang', *Apollo*, 138, no. 379, 1993, pp. 102–75

J.M. Robinson, *Royal Palaces: Buckingham Palace*, London, 2007

F. Russell, 'King George III's picture hang at Buckingham House', *Burlington Magazine*, 129, August 1987, pp. 524–31

J. Shearman, *Raphael's Cartoons in the Collection of Her Majesty The Queen*, London, 1972

J. Shearman, *The Early Italian Pictures in the Collection of Her Majesty The Queen*, Cambridge, 1983

G. Waterfield (ed.), *Palaces of Art: Art Galleries in Britain 1790–1990* (exh. cat.), Dulwich Picture Gallery, London, 1991

G. Waterfield, 'The town house as a gallery of art', *The London Journal*, 20, 1995, pp. 47–66

C. White, *The Later Flemish Pictures in the Collection of Her Majesty The Queen*, 1st edn, London, 2007

C. White, *The Dutch Pictures in the Collection of Her Majesty The Queen*, rev. edn, London, 2016

Index of Artists

—◇—

Published 2020 by Royal Collection Trust
York House
St James's Palace
London SW1A 1BQ

Published on the occasion of the exhibition *Masterpieces from Buckingham Palace* at The Queen's Gallery, Buckingham Palace, London, in 2020.

ISBN 978 1 909741 73 7
102313

British Library Cataloguing-in-Publication Data:
A catalogue record for this book is available from
the British Library.

Editors: Alison Effeny and Sarah Kane
Designer: Paul Sloman | Subtract Design
Project Manager: Elizabeth Silverton
Production Manager: Sarah Tucker
Colour reproduction: Alta Image
Typeset in Sorts Mill Goudy
Printed on 150gsm Arctic Matt
Printed and bound in Wales by Gomer Press

Front cover: *Portrait of Agatha Bas*, oil painting by
Rembrandt van Rijn, 1641 (cat. 38)

Facing title page: *The Picture Gallery, Buckingham Palace*,
watercolour by Douglas Morison, 1843 (RCIN 919916)

Page 4: *Judith with the Head of Holofernes*, oil painting by
Cristofano Allori, 1613 (detail from cat. 9)

Page 32: *The Mystic Marriage of St Catherine*, oil painting by
Sir Anthony van Dyck, 1630 (detail from cat. 31)